Mark Rosenthal · Franz Marc

Mark Rosenthal

# Franz Marc

Prestel

© 1989 Prestel-Verlag, Munich

© of works illustrated by the artists, their heirs and assigns,
except in the following cases: Robert Delaunay by VG
Bild-Kunst, Bonn, 1989, Henri Matisse by Cosmopress, Geneva, 1989.

© 1979 "Franz Marc: Pioneer of Spiritual Abstraction" by
The Regents of the University of California
This essay, with some minor changes,
was initially published by the University Art Museum,
University of California, Berkeley,
on the occasion of the first Franz Marc exhibition
in the United States, in 1979.

Cover illustration: *Deer in a Monastery Garden,* 1912 (pl. 34, detail)
Frontispiece: Franz Marc, c. 1913

Prestel-Verlag, Mandlstrasse 26, D-8000 Munich 40, Federal Republic of Germany

Distributed in continental Europe and Japan by Prestel-Verlag,
Verlegerdienst München GmbH & Co KG,
Gutenbergstrasse 1, D-8031 Gilching, Federal Republic of Germany

Distributed in the USA and Canada by te Neues Publishing Company, 15 East 76th Street,
New York, NY 10021, USA

Distributed in the United Kingdom, Ireland and all other countries by Thames & Hudson Limited,
30-34 Bloomsbury Street, London WC1B 3QP, England

Designed by Dietmar Rautner, Munich
Offset lithography by Karl Dörfel Repro GmbH, Munich
Typeset by Fertigsatz GmbH, Munich
Printed by Wenschow-Franzis GmbH, Munich
Bound by R. Oldenbourg GmbH, Munich
Printed in the Federal Republic of Germany

ISBN 3-7913-1024-0

# Contents

# Franz Marc: Pioneer of Spiritual Abstraction

Franz Marc was a shooting star of German Expressionism. His absorption of a nineteenth-century, pantheistic orientation within the twentieth-century language/religion of abstraction and then his early death in the conflagration of World War I was the path of the tragic Expressionist figure *par excellence*. This artist-hero experienced his subject matter thoroughly, attached symbolic significance to his style, and lived his life as a Faustian character. In doing so, Marc helped establish a branch of abstraction that, as opposed to Cubism in France, was content-filled, spiritually inclined, and zealous in its aspirations.

Marc's grounding was in German Romanticism.[1] Although he felt himself on the brink of a new era, it was one founded on nineteenth-century conceptions and assumptions having to do with the place of the human in the universe. In the musings of the nineteenth-century Romantics, and then Marc, may be found a distinct strain of insecurity. At one moment humanity subordinates itself to or alienates itself from the largest forces; at the next instance it empathizes with nature, then transcends human limitations in a godlike flight of release. Constant throughout is a great, corresponding drama of emotions which fluctuate between despair and exaltation. Not exclusively German, the confrontation with traumas of the most cosmic or personality-shattering nature can be seen in figures such as Feodor Dostoevsky, August Strindberg, Vincent van Gogh, and Edvard Munch, and in the Viennese sphere at the turn of the century. The first burst of German Expressionists, *Die Brücke* (the Bridge) group, including Ernst Kirchner, Emil Nolde, Karl Schmidt-Rottluff, and others, attempted to master their traumatic dislocation from culture and fear-yearning for nature through the medium of art. But while they portrayed the upheaval, Marc and Wassily Kandinsky, founders of the second wave called the *Blaue Reiter* (Blue Rider), felt that, with art, they could embrace their subject matter holistically, either by means of abstract correspondence and strategy or by the symbol. No less culturally alienated than the *Brücke* artists—this alienation being probably the single most unifying character of the Expressionist orientation—Marc and his colleagues, in contrast, evolved a more cosmic and transcendent attitude. Urban disintegration became apocalypse, and dramatic sexuality was replaced by the idea of spiritual union with the cosmos. Still an outcast, like Dostoevsky or Kirchner, Marc now had a religious mission and a positive goal, one that made use of the metaphoric and compositional possibilities of abstract art.

# Beginnings (1880-1907)

Marc was born on February 8, 1880, in Munich. According to his first biographer, Alois Schardt, Marc was so ugly at birth that his father, when taking a first close look at his son at baptism, fainted. Undeterred by the family's reaction, Marc quickly emulated their character, becoming known, while still a baby, as the "little philosopher."[2] His father, Wilhelm, was a landscapist of "curiously philosophical character," according to Franz; his mother, Sophie (pl. 1), was an Alsacian from a strict Calvinist tradition. Marc's grandparents were amateur artists who copied the masters. They and his great grandparents were aristocrats, with friends among artists as well as people of letters.[3]

Following the lead of his family, Marc studied theology intensely. The family contemplated both the spiritual essence of Christianity and its cultural responsibilities. Marc was sufficiently moved by this background and his confirmation in 1894 that, for the next five years, his goal was to become a priest. But he mingled with his theological studies the Romantic literature of both England and Germany. This combination continued to affect him for years to come; in 1915 he wrote: "You must not think that I read the Bible poetically. I read it as truth as . . . I see pure art as truth."[4] Philosophy, especially Friedrich Wilhelm Nietzsche's thought, was joined with theology among Marc's pursuits. Finally, near the end of 1898, Marc gave up his goal of becoming a priest to study philosophy at the University of Munich. But suddenly, in 1900, this ethical, high-minded youth turned to art. He studied drawing first with Gabriel Hackl and then painting with Wilhelm von Diez, both at the Munich Academy.

In the first years of the twentieth century, artistic training in Munich emphasized the traditional verities of academic naturalism and studio production. French Impressionist color innovations were still largely unknown, as can be witnessed by the tonalities of green, brown, and grey in Marc's *Alpine Landscape with Herd of Sheep,* 1902-03 (fig. 1). Appropriately transcendent and Romantic, the lonely herder is shown high on an alpine peak, in the clouds. The small human figure is juxtaposed with the grandeur of nature in a sensuous yet controlled rendering. By juxtaposing the vertical motif of the figure with the grand horizontals of the earth and the dense space of the clouds, the composition suggests a contrast between opposing elements. At this early stage in his development, Marc reflects the thematic concerns of such predecessors as Caspar David Friedrich in that the human

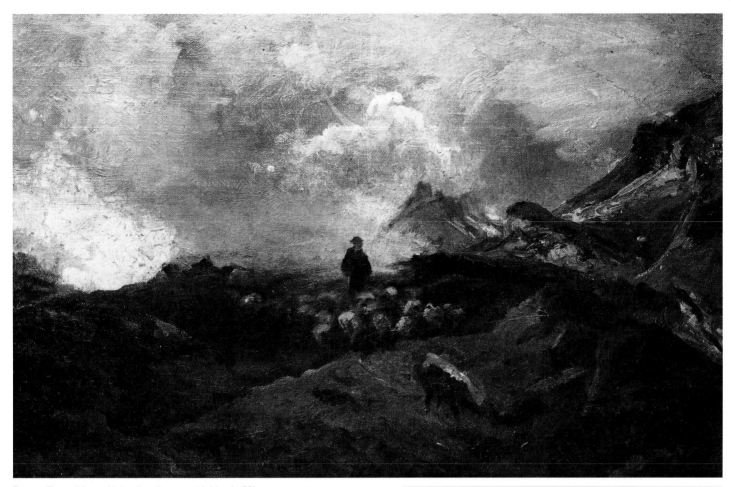

Fig. 1    Franz Marc, *Alpine Landscape with Herd of Sheep*, 1902-03

Fig. 2    Franz Marc, *The Dead Sparrow,* 1905, Dr. Erhard Kracht
Collection, Norden

Fig. 3    Franz Marc, *Moulting Hen,* 1906, Private Collection, Boston

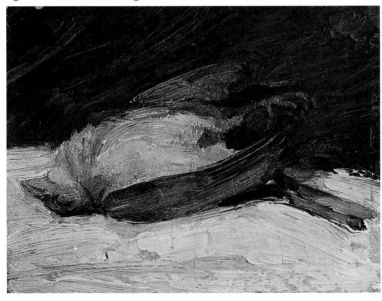

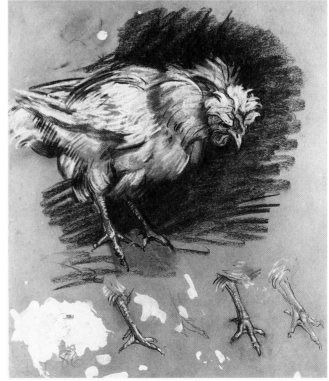

being is dwarfed by the awesome appearance of nature. The sheep are coloristically related to the earth and barely stir our notice.

Marc's stiff studio style begins to undergo a transition in subsequent years due to a variety of French influences. A trip to Paris in 1903 initiated an interest in Impressionism and *plein air* studies and a more contemporary use of color, as seen in *Indersdorf*, 1904 (pl. 2); the trip also reinforced the impact of two-dimensional simplification of color and line found in the German version of *Art Nouveau* called *Jugendstil. The Dead Sparrow*, 1905 (fig. 2), and *Moulting Hen*, 1906 (fig. 3), confirm this new direction in Marc's art. His line is now energized and vivid, and his depiction of nature is inspired to a degree that predicts his later views of vitalized animals and landscapes. In contrast to the dreaminess of *Woman in the Forest with Wood Cart*, c. 1904 (fig. 4), Marc's approach, both narratively and stylistically, has become more sensual.

Unfortunately, Marc's artistic development was accompanied by melancholy and upheavals in his emotional life. His religious outlook was at odds with the Munich youth movement[5] and the city's burgeoning bohemian atmosphere. He spent summers in the mountains in 1905 and 1906 as well as travelling to Greece in 1906, attempting to recuperate from unhappy love affairs. On his return from Greece, still depressed, he wrote, "At present I have only one purpose in life—to drown it in my painting...and to strangle all the passionate vital instincts."[6] Some indication of Marc's pessimism is evident in a book he illustrated between 1904 and 1909 entitled *Stella Peregrina* (figs. 5 and 6). Powerful *Jugendstil* contours are employed in the delineation of gloomy poetic themes. Choosing subjects of Romantic escape, Marc was especially attracted to the freedom of flight possessed by birds. This period of anxiety came to a tumultuous end when, on his wedding night, following marriage to the painter Marie Schnür, he left for Paris. That summer, in 1907, his marriage was dissolved.

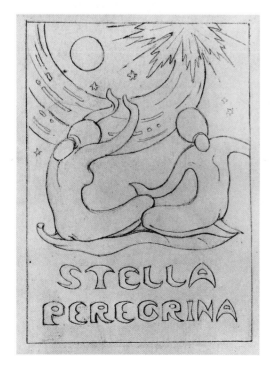

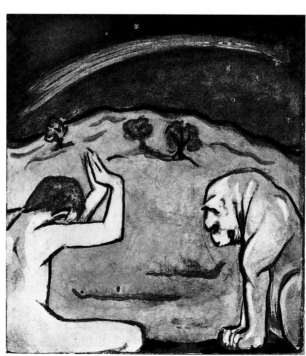

Figs. 5/6   Franz Marc,
*Stella Peregrina*, 1904-09
Book by Franz Marc
(Munich 1917),
*Title page* and *There a Star Fell*
Robert Gore Rifkind Center
for German Expressionist
Studies, purchased with funds
provided by Anna Bing Arnold,
the Museum Acquisition Fund
and Deaccession Funds

Fig. 4   Franz Marc,
*Woman in the Forest with
Wood Cart*, c. 1904
Rudolf Hirsch Collection,
Swarthmore, Pennsylvania

# Evolving a Style (1907-1910)

Marc's sudden trip to Paris in 1907 marks a major turning point in his career. Apparently freed from his period of despondency, he came under the influence of Paul Cézanne, Paul Gauguin, and van Gogh, all of whom had a profound impact on the young artist. Van Gogh immediately fit Marc's mood:

*Van Gogh is for me the most authentic, the greatest, the most poignant painter I know. To paint a bit of the most ordinary nature, putting all one's faith and longings into it—that is the supreme achievement.... Now I paint... only the simplest things.... Only in them are the symbolism, the pathos, and the mystery of nature to be found.*[7]

Marc and van Gogh were clearly kindred spiritis. Each saw life in religious yet tortured terms, and each found transcendent effects in insignificant themes, echoing Symbolist notions. Like van Gogh, Marc possessed the idea of the artist as martyr.

While in Indersdorf in the summer of 1907, Marc painted *Sheaf of Grain* (pl. 3), a clear evocation of van Gogh's influence. The field with the bundle of grain, rendered in blond tones, is an echo of the Dutchman's art in such works as *Harvesting Wheat in the Alpilles Plain*, 1888. Also, the energetic linear quality that was seen earlier is further accentuated in a manner clearly derived from van Gogh and Impressionism generally. In contrast to his previous landscapes, *Sheaf of Grain* presents nature as if seen from its own vantage point, rather than from that of a Romantic, longing individual. Nature is fully alive and accessible, instead of appearing distant and impenetrable, as in the earlier landscapes. Furthermore, the image of bundled grain represents nature that has been touched by humanity, as opposed to what is depicted in *Alpine Landscape.*

These modifications of the Romantic outlook were manifestations, too, of the powerful back-to-nature sentiments that existed in Germany at this time. Present in places as diverse as the pages of *Simplicissimus*, a popular satirical journal, as well as such artists' alliances as the Worpswede group and *Die Scholle* was the idea that somehow life was more authentic when integrated into a natural setting. Vivid, energized landscapes and bathers of a primitivistic character became symbols of this sensibility for many avant-garde German artists of the period. Marc, too, looked to nature for inspiration.

The year 1907 marks the beginning of his sustained preoccupation with a variety of animal subjects.[8] Beside an anatomical interest in these, as in his few pieces of sculpture, Marc's constant thematic concern is the relationship between animal and human spheres. For example, a relationship is suggested in the depiction of zoological subjects, Leda and the Swan, Marc's friend Jean Bloé Niestlé surrounded by birds, a woman holding a cat in a gesture similar to that of the Madonna, and the theme of Orpheus entrancing several creatures.[9] The shepherd with his herd appears in a number of the early drawings, too. Symbols of Christ's flock, the numerous sheep drawn between 1902 and 1908 may even be meant to subsume Marc himself, given his deeply religious outlook and grounding. In an illustration for *Stella Peregrina* (fig. 6), he joins a figure and lion in parallel, prayerful poses as if to suggest God's creatures are equal in stature. Thus, Marc's feeling for animals extends from studying to shepherding to interacting to identifying with to joining them.

One reason for Marc's interest in animals was that they represented, for him, a spiritual attitude. He wrote: "People with their lack of piety, especially men, never touched my true feelings. But animals with their virginal sense of life awakened all that is good in me."[10] Hence, a critical element in Marc's turn to this subject was a feeling that animals were somehow more natural or pure than people. Moreover, he believed that through animals he could represent his own spiritual feeling.

In *Deer at the Edge of the Forest (Herd of Deer)*, 1907 (pl. 4), Marc presents eight deer spread within a stage space. The animals are in diverse poses, recalling Antonio Pollaiuolo's didactic exercise of fighting figures (fig. 7). Also reminiscent of the Renaissance is the device of the deer at the right whose hindquarters lead us into the picture. Though an Arcadian spirit seems to prevail, the painting also holds a sense of dark, blue mystery reminiscent of the Nabis, a group of French Symbolist artists, and Marc's

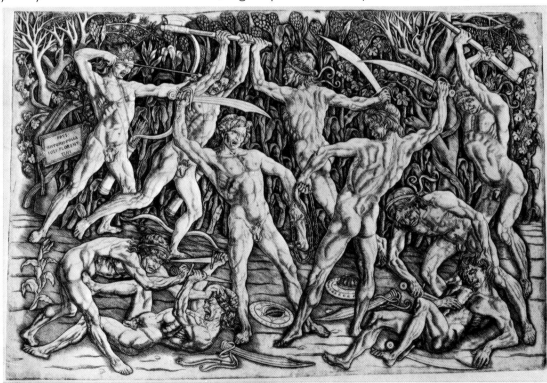

Fig. 7  Antonio Pollaiuolo,
*Battle of Naked Men*, c. 1464-74

earlier *Woman in the Forest* (fig. 4). The possibility that he could have been influenced by figurative examples is suggested not only by comparison with Pollaiuolo but by a comment of 1907, in which Marc speaks of himself as someone "who feels like a fawn, which passes through a magical forest, for which it had always been yearning."[11] The correspondence he draws between his own existence and that of an animal is a logical development from German Romantic evocations of a human mood expressed by a landscape. Marc has also centered his sentiment elsewhere, in the mood of another creature.

Marc's most important work of 1908 is *Large Lenggries Horse Painting I* (pl. 6). Although he had done several small horse subjects earlier, this work was the largest and most significant to survive. That it survived is accidental. Marc had cut the painting in pieces and used it to pad the roof of his home in Sindelsdorf. Only in 1936 was the painting found and restored. *Lenggries Horse Painting* announces Marc's engagement with the major theme of his career, the horse.

A vivid subject on the Parthenon, the horse became a Romantic motif in the work of the eighteenth-century Englishman George Stubbs. While Marc probably knew nothing of Stubbs's fearsome depictions, he certainly would have been familiar with the work of Théodore Gericault and Eugène Delacroix. In French hands, the heroic horse joined brave cavalry officers or was shown in untamed situations. It was symbolic of nature in its uncontrolled state. Géricault presented the horse in other ways as well, including "portraits" and domestication. The range of Géricault's portrayals, together with the constant interest in the horse for its raw brute energy, would have been the most significant precedent for Marc's own interpretations. The French Romantic theme of the horse was repeated by nineteenth-century Germans, including Adolf Schreyer and Hans von Marées. Late in the century, Edgar Degas portrayed numerous horses in both painting and sculpture, just as Marc would do. Rarely did the Frenchman show the horse alone, however. Rather, his horses usually appear in the civilized setting of racetracks where the artist studied the gestures of the animals and riders together. In contrast, Gauguin, in *The White Horse*, 1898, combined nudes with horses in an image of profound naturalness and quiet. His picture predicts the attitude in Marc's horse renderings of 1913.

Schardt gathers together all of Marc's paintings of horses in what he terms the "Lenggries Horse theme," saying it was one subject with which Marc struggled continually. Apparently, Marc followed the animals for months in their meadow in the village of Lenggries, near the Austrian border, working to eliminate detail and reduce his renderings to only essentials.[12] The result is still related to van Gogh by the blond tonality and to *Sheaf of Grain* by the emphasis on curvilinear forms. *Lenggries Horse Painting*, like *Deer at the Edge of the Forest*, has a relatively shallow space in which the animals are shown in a variety of poses. All but one of the nearly life-size horses are faced to the left; one is absorbed by the earth; one is turned on itself; and the other two stare as if hypnotized. Three of the horses, united by their orange and yellow tones, form a semi-circle. The fourth is pink; its terrified look is reminiscent of antique statuary and suggestive of death. Reinforcing this possible interpretation is a drawing of a few months earlier, *Head of a Dead Horse*, 1907-08 (fig. 8), in which the visage is nearly identical.

*Lenggries Horse Painting* is perhaps the first work in which Marc reveals himself as the great colorist he would become. The application of paint is virtuosolike. A light, airy quality, conveyed by the

14

Fig. 8 Franz Marc, *Head of a Dead Horse,* 1907-08
Städtische Galerie im Lenbachhaus, Munich, Estate

thinly applied pigment, vitalizes the scene. The painting foreshadows the ambitious yet abandoned color and paint application of his most accomplished works and shows Marc beginning to juxtapose primary colors in a single image. Orange in tonality, the horses have become visions unrelated to the palette of nature's horses.

Writing in 1910 about an unnamed large horse painting, Marc discusses the use of white behind red, yellow, and blue to suggest a wall, as if a fresco.[13] This effect appears in the white expanse directly above the pink horse of *Lenggries Horse Painting* but is interrupted by a blue area. The relationship of colors predicts another, later discussion in which Marc wrote that the "shrewlike" quality of orange makes blue "indispensable."[14] Responding in this way to color became a hallmark of Marc's approach in subsequent years.

While Marc had painted horses earlier, those versions often portray domesticated or placid animals. But *Lenggries Horse Painting* introduces the enormous vitality and vivid rendering that would characterize later paintings. It also shows another aspect typical of Marc's mature work—animals arranged rhythmically, yet with each indicating an individual and potentially emotional or symbolic attitude. This unity within which individuality of gesture exists is strikingly reminiscent of images by Ferdinand Hodler (fig. 9), an artist well known in Marc's time, as well as other large figurative composi- tions Marc would have been familiar with by von Marées, Cézanne, and Henri Matisse. In Hodler, parallel yet differing gestures indicate divergent spiritual states.

Between 1907 and 1910 Marc painted various parallel phenomena, including figures, animals, and rocks, as rhythm became the basic compositional device of his work. *Siberian Sheepdogs (Siberian Dogs in the Snow),* 1909 (pl. 8), shows him exploring this organizational effect, in which his dog, Russi, is repeated to form a forceful, stolid rhythm.

In 1909, at the Berlin Secession exhibition of that year, Cézanne's *Great Bathers* was shown. It was not only a summation of the traditional bather theme but an affirmation of the direction taken by

15

Fig. 9   Ferdinand Hodler, *Night,* 1890, Kunstmuseum, Berne

*Brücke* painters who rendered many images of a primitive paradise. For them, the theme unites various cults regarding human regeneration and the superiority of a natural life into an image of humanity unadorned, in its pure state. For all intents and purposes absent earlier, the subject of figurative nudes began to appear in Marc's art from the time the Cézanne was shown (pls. 10 and 11).

The similarities between the figurative works and the animal subjects, especially with regard to poses evocative of either contemplation, dream, or self-absorption, reinforce the likelihood that Marc transferred to the animal attitudes one associates more easily with humanity. Indeed, his statement in December 1908, that he was working "toward an animalization of art..."[15] came be amended. Marc had objectified humanity in animal form, and created a personal symbol for himself. For instance, an animal such as the one in *Horse in the Landscape*, 1910 (pl. 13), seems to have assumed the reverential and thoughtful quality usually the province of human beings, while the latter may more often appear in anecdotal or contrived poses. The potential for human suffering and longing that characterized German Romanticism has thus been diminished.

In addition to formulating a subject matter with which he felt he could project his Romantic, empathetic thinking, and establishing the significance of gesture as evocative of attitude, by 1910 Marc had begun to assert an independent use of color. Having destroyed a number of large canvases during the preceding two years, he was now able to create the splendid and exuberant juxtapositions in *Horse in the Landscape* due to several events in 1910. First is Marc's meeting in January 1910 with August Macke, an artist who was to deepen Marc's understanding of the coloristic advances in France. Exhibitions of Gauguin and Matisse in Munich further awakened him to the possibilities of composition based purely on color relationships that exist apart from naturalistic representation.[16] These formal problems assumed topical interest when an avant-garde exhibition in Munich in September 1910, by a group known

16

as the *Neue Künstlervereinigung* of Munich, was attacked in the press. Marc defended them in print, subsequently joined the group, and became a close friend of Wassily Kandinsky, chief spokesman of the *Neue Künstlervereinigung,* early in 1911. There followed internal conflict within the group to the extent that Marc and Kandinsky separated from it in 1911 to form the Blue Rider group. By 1910 Kandinsky had reached maturity after absorbing the color achievements of the French *Fauves*, a group of artists including Matisse, André Derain, and Maurice de Vlaminck, who used bold colors in a compositional rather than representational manner. Contact with Kandinsky quickly brought Marc to his own plateau of accomplishment.

# Maturity (1911)

Marc must have recognized that *Horse in the Landscape*, 1910, signalled a formal and thematic breakthrough, for at the start of 1911 he painted a large sequel entitled *The Red Horses* (pl. 14), a work which consolidated and advanced his new maturity. Still rendered with light impasto, like the *Lenggries Horse Painting*, *Red Horses* departed from that canvas with the rich formal relationship created between the animals and the landscape, as reflected in the rhythmic curves uniting the torsos and hills. Color is now raised to a brilliant pitch, as the red of the horses contrasts to the blue rocks in the right corner and the yellow ground. In the upper third of the painting, Marc mixed the primaries to produce pinks, violets, and greens, which build toward the mostly white sky.

By early 1911 Marc had already developed a symbolism for his use of color. In this, he followed a pattern established earlier by Johann Wolfgang von Goethe, Philipp Otto Runge, an early-nineteenth-century German Romantic painter, and Marc's friend Kandinsky. Marc ascribed spirituality and maleness to blue, femininity and sensuality to yellow, and terrestrial materiality to red.[17] The context in which Marc worked suggests he employed these correspondences programmatically, for Kandinsky was extremely serious about color symbolism, and the Symbolists, with whom Kandinsky and Marc had much in common, were likewise interested in such ideas. Marc wrote: "Every color must say clearly 'who and what' it is, and must, moreover, be related to a clear form."[18] Such strength of purpose is particularly apparent in the paintings of 1911.

In *Red Horses*, the depiction is sufficiently simplified so as to allow the color to be paramount. The dynamic red of the horses suggests that Marc intended to emphasize an earthly orientation for this particular group of animals. The white area surmounting the pyramidally arranged horses can be understood as symbolizing purity or solace in comparison to the rest of the canvas. To interpret Marc's use of green in the upper third of the painting with regard to his thoughts on color is also enlightening. He said that once green is introduced, "you never entirely bring the eternally material, brutal red to rest." In that spirit, the horses seem nervous beyond all possibility of resolution. Only the blue, as Marc prescribed, lends a peaceful note to the agitated atmosphere.[19]

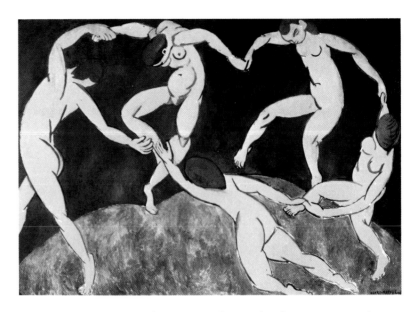

Fig. 10   Henri Matisse, *The Dance*, 1909-10
Museum of Modern Art, Moscow

While Marc has employed in *Red Horses* an absolutely arbitrary palette, he has not sought to flatten color into planes as the *Fauves* had done. Rather, he retains an illusionistic portrayal within which he seeks to form a rich color composition that reflects the vitality of his subject. The principal achievement in *Red Horses* is this depiction of the uninhibited energy of nature using completely unnaturalistic colors. Vitality by virtue of a coloristic boldness recalls Matisse, particularly in *The Dance* (fig. 10), a work chosen by Marc and Kandinsky sometime in 1911 for reproduction in the yearbook of the Blue Rider group, entitled *Der Blaue Reiter* (and often referred to as the *Blaue Reiter Almanac*). As in Matisse's canvas, unification of figure and ground is accomplished by repeating curves; the effect of a dance in the arrangement of the horses can be confirmed by an earlier version of this work.[20]

Marc employs a triangular composition for the animals in *Red Horses*, as opposed to the more casual grouping in *Lenggries Horse Painting*. While the design is fundamentally static, the manes establish a vibrant set of curves within the triangle. This device, together with the brilliance of the reds, causes an intensity about the animals that belies the stasis of the triangle. As in the earlier *Lenggries Horse Painting*, or *Bathers*, 1910, the horses exhibit different attitudes. These closely parallel horses seen in earlier works suggest a kind of program in Marc's approach. The lower-left animal is extremely agitated and has an air of undirected, potent energy. In contrast, the one on the right is engaged in seeking food, his head bringing him in contact with the earth. Both of these foreground horses in *Red Horses* seem completely "animal," but the third stares out contemplatively toward the white sky and the landscape, echoing the situation depicted in *Horse in the Landscape* and suggesting Romantic longing.

While also filled with an animal physicality, the contemplative horse is differentiated coloristically and seems human in its sensitivity.[21] The relationship of animals to humanity in Marc's iconography is provocatively restated if three works of 1911 are compared: *Young Boy with a Lamb (The Good Shepherd)* (pl. 21), *Woodcutter* (pl. 22), and *Blue Horse I* (pl. 19). All three "figures" blankly look to the ground with a similar turn of the head and melancholy attitude. Typifying the woodcutter's character, in contrast to the horse, his physique only slightly echoes the landscape. The shepherd's body does exhibit

a unity with his surroundings, thus suggesting his status within Marc's iconography as a Christian devoted to animals.

Envious of the naturalness of animals, Marc, as is frequently noted, sought somehow to observe nature from an animal's point of view. In that spirit, he wrote an essay entitled "How Does a Horse See the World?"[22] It is debatable whether Marc envisioned the horse seeing its own physical characteristics in the surrounding environment. More likely, he intuited that the animal physique manifests a mystical oneness with nature, a oneness for which mankind, including Marc, yearns.[23] Thus, while in general terms the animal stood for a state beyond humanity, it could, as well, symbolize the artist himself. For him, yearning to take animal form merged with his use of the animal as a metaphor of the vitality of nature.

On occasion, Marc depicted the vibrant character of nature with little reinforcement by animals, as in *Weasels at Play*, 1911 (pl. 16). The landscape is brightly hued, and the colors are applied in flat areas. The arabesque tree trunks and branches are reminiscent of *Art Nouveau* formulae, and recall Matisse and Derain once more.[24] Marc may have been describing *Weasels* in discussing a certain landscape in 1911:

*Instead of painting trees in a complementary way in their light, core, and shadow sides and in their relationship to the ground and background, I paint one pure blue, the next pure yellow, green, red, violet, and so on . . . . In the same way, I separated the colors of the ground and the bushes into single, delineated parcels of pure color which I divide over the entire painting with artistic taste and instinct (but without precise consideration of the relative positions of complementary colors).[25]*

With *Red Horses* and *Weasels*, as well as *Deer in the Snow*, 1911 (pl. 15), Marc was reaching the point of genuine maturity. Coloristic freedom and composition had become integrated with his vision of nature. The resulting effect recalls a similar one described by Goethe: "The artist brings down the Divine to earth, not by letting the Divine flow into the world, but by raising the world into the sphere of Divinity. This is the cosmic mission of the artist."[26]

Paralleling Marc's artistic evolution was the emotional peace he achieved upon marrying Maria Franck in the summer of 1911, on a trip to England. Maria may have inspired the magnificent *Yellow Cow*, 1911 (pl. 17), especially as yellow is the color of femininity for Marc. Supporting this possibility is an interpretation of *Blue Horse I*, of the same year (pl. 19), as epitomizing Marc's mood.[27] In each case, Marc's color symbolism reinforces exaggerated archetypal portrayals: The male blue horse is contemplative and spiritual; the yellow female is active and sensual.

The antic *joie de vivre* of the *Yellow Cow* is the first and perhaps the only case in Marc's career of a joyous animal. It is totally abandoned to play. As Klaus Lankheit points out, Marc avoids the typically human, sentimental view of animals.[28] Rather, the cow has surrendered to its nature, as it were. It gestures in a mime language, like those poses in Hodler which also speak of metaphysical states. This animal emotion perfectly evokes the concept proposed by Kandinsky called "inner necessity," by which is meant the essence of feeling determined by whatever physical and cultural circumstances pertain. A

20

unity between the cow and nature is indicated coloristically by the repetition of the animal's yellow cast just to the right of the head, the white of the udder in the area below, and the blue spots in the mountains beyond.

Yellow, Marc's symbol of femininity and sensuality, is shown in *Yellow Cow* with such intensity that the artist requires nearly equal doses of red and blue. Marc wrote: "I am trying to enhance my sensibility for the organic rhythm that I feel is in all things ...";[29] therefore, the sharp juxtaposition of the primaries supports a natural vibrancy and results in a kind of random, nearly chaotic, synesthetic quality that characterizes Kandinsky's contemporaneous work and also many of Marc's best paintings.

According to Marc's program, the yellow feminine principle is closely related to the material red of the earth, whereas the blue, or male, element is more distant. Hence, juxtaposed with the vitality of the cow are the blue triangular mountain peaks which sound an important, contrasting note. Such peaks first appear in Marc's work in the latter part of 1911 and then continue for the rest of his career. While the major implications of his association with Kandinsky and the Blue Rider group will be discussed more fully later in this essay, certain aspects of the relationship must be considered in relation to the mountains in *Yellow Cow.*

Kandinsky wrote *Concerning the Spiritual in Art* in 1911, at the time *Yellow Cow* was painted. In that book he emphasized the significance of the triangle as a symbol of the striving soul of the individual and humanity in general.[30] So important was the triangle to Kandinsky that he employed it as part of his signature in nearly all his prints throughout his career.[31] Kandinsky dealt in typological parallels; for example, he wrote of the abstract impact of the triangle equalling the finger of God in Michelangelo's Sistine ceiling.[32] (In a similar spirit, the horse and rider later become equated with a circle.) In the course of his 1911 discussion of the triangle and its hierarchical segmentation into spiritually advanced and conventional layers of human awareness, Kandinsky interjected another parallel: "An invisible Moses descends from the mountains and sees the dancing around the golden calf."[33] With this description, the mountain, a prominent form in Kandinsky's paintings of 1911-14, possesses the same meaning he ascribed to the triangle. Marc, who was already a close friend of Kandinsky in 1911, was to write of him that "at least there is a man who can move mountains—and how grandly he has done so; to know this is inexpressively reassuring."[34] Later, Paul Klee, another associate, would also employ the triangle-mountain with great frequency.[35]

Because of the importance of this form to Kandinsky, and the subsequent adaption by Marc and Klee, the triangle-mountain was likely a logo of Blue Rider amibitions by the time *Yellow Cow* was created. Given Marc's identification of blue with maleness, and the probability that *Blue Horse I* is to a degree a self-portrait, the blue mountain can be seen as the embodiment of Marc's aspirations—artistic and otherwise—which in their spirituality complement the yellow sensuality of the cow. If the yellow cow is somehow symbolic or evocative of Maria, and the blue mountains verges on being Marc himself, then *Yellow Cow* becomes a kind of wedding picture for the newly married couple.

Following *Red Horses* and *Yellow Cow,* Marc completed his suite of monumental, primary-color compositions in 1911 with *The Large Blue Horses* (pl. 20). He returned to the *Large Lenggries Horse*

*Painting* (pl. 6) for the pose of the animals and for the semi-circular arrangement, with all pointing to the left. The grouping of animals is rather awkward and bulky, as they are bunched in a small, constricted, entirely blue area, with the viewer's vantage point close to the action. Compositionally, the animals are more fully integrated with a hilly landscape than was the case in *Red Horses*, for the curvilinear rhythm that characterizes the torsos is repeated precisely in the hills.

Whereas in *Yellow Cow*, all of the primary colors sound important tones, the blue of the horses is contrasted for the most part by the red alone. Marc's discussion of his color symbolism suggests that in *Blue Horses* we witness the harsh struggle by the blue, *geistig* force of intellect and spirituality against the nearly overbearing weight of matter, shown as red. In this struggle, yellow can serve as a comforter, according to Marc.[36] The theme of group struggle is reinforced by the fact that in *Blue Horses*, as opposed to *Lenggries Horse Painting* and *Red Horses*, the gestures of the animals are barely distinguished. As in Matisse's *Dance*, all the heads look down. In human terms, the three are joined by a common purpose which individuality might subvert. Above, the free-floating green passages are reminiscent of Kandinsky's contemporaneous work.

In contrast to the *Yellow Cow* framed by four black tree trunks or branches, the horses are encircled, almost like a halo, by a pair of white lines. These recall the long, abstract, free-floating lines that were frequently present in Kandinsky's work, yet remain treelike in character. Later, in the apocalyptic *Fate of the Animals*, 1913 (pl. 55), and *The Unfortunate Land of Tirol*, 1914 (pl. 57), similar treelike forms fall on various animals, causing their death.

*Blue Horses* is symbolically bound to certain of the originating conceptions of the contemporaneous Blue Rider group: in the symbol of the horse as a vehicle of breakthrough, in the emphasis on the spirituality of blue, and in the idea of spirituality battling materialism. That Marc had employed four horses in his earlier composition of the *Lenggries Horse Painting* and reduced the number to three in 1911 may reflect the further influence of Kandinsky, who, following theosophical practice, employed three instead of four horses as reflective of the apocalypse.[37] But the absence of a rider is in keeping with Marc's own belief in the supremacy of animal spirituality over that of humans.

Kandinsky wrote that the public was outraged by Marc's coloristic digressions from reality. They were seen as *épater le bourgeois*, according to Kandinsky,[38] much in the spirit of the *Fauves* of France. However, this public reaction was a misunderstanding of Marc's ambitions, which can be extrapolated from his admiring statement of 1910 regarding the *Neue Künstlervereinigung*. He wrote that the Germans "wanted to create contemporary symbols that could be placed on the altars of the spiritual religion of the future...."[39] In 1911 Marc did this himself with his brilliantly and symbolically colored animals which were intended to evoke a new vision of spirituality.

# Der Blaue Reiter (1911-1912)

When Marc and Kandinsky broke with the *Neue Künstlervereinigung* in the summer of 1911, they were not content to start a rival artists' association, but sought to establish a new way of understanding the history and the future of art. Although Kandinsky was older, more knowledgeable, and a mentor to Marc, they evolved their theoretical position together. The Russian was later to say that the original plan was his own;[40] nevertheless, he refused to continue the enterprise after Marc's death.[41] Symptomatic of their united concern for the new movement was the name for the group which neatly joined Kandinsky's longtime subject of horse and rider to Marc's interest in the horse. Marc and Kandinsky decided first to produce a publication, *Der Blaue Reiter*,[42] that would clearly establish their ideas and goals. While two Blue Rider exhibitions followed the publication of *Der Blaue Reiter*, the "group" was never more than a loose alliance, including, among others, Kandinsky, Marc, Klee, Macke, Albert Bloch, Gabriele Münter, Heinrich Campendonk, and David and Vladimir Burliuk.

Key to the Blue Rider was the belief in an approaching new epoch, one that was antimaterialist and spiritually inclined. Like the earlier German avant-garde known as *Die Brücke*, which had already announced a break with contemporary culture, the artists believed in a new world community and an altered definition of humanity. But Blue Rider thinking was in contrast transcendent. Especially pertinent was the desire, inherited from Romanticism, for unity with the universe and a cosmic system of reference points.

"We stand today at the turning point of two long epochs," Marc wrote in *Der Blaue Reiter*.[43] To help establish the new epoch, artists had in effect to destroy conventional appearance which symbolically stood for the old order. Marc said: "The creative artist honors the past by leaving it alone."[44] He wanted to create new traditions and symbols to accompany the advancing epoch he foresaw. In the spirit of a new religious crusade, Marc announced the situation to *Der Blaue Reiter* readers at the start of his essay entitled "The 'Savages' of Germany":

*In this time of the great struggle for a new art we fight like disorganized "savages" against an old, established power. The battle seems to be unequal, but spiritual matters are never decided by numbers, only by the power of*

*ideas. The dreaded weapons of the "savages" are their new ideas. New ideas kill better than steel and destroy what was thought to be indestructible.*[45]

The missionary zeal of Marc's call to arms indicates the degree to which the movement was as much social as artistic. The assumption exists, too, that great art requires religion.

One of the primary aspects of *Der Blaue Reiter* was the synthesis of various kinds and traditions of art under one umbrella. This was carried out particularly through the illustrations which combined, for example, tribal, folk, and children's art with that of Cézanne and Henri Rousseau. The choices for illustration indicate not only a break with tradition but a rupture with "high art" as practiced in Europe. In discussing his attraction for the art found in ethnographic museums, Marc wrote: "It seems obvious to me that we should look for rebirth in the cold dawn of that kind of artistic intelligence and not in cultures like the Japanese or the Italian Renaissance."[46] The works reproduced were then of little financial value; in contrast, Marc wrote of an appreciation for the likes of Peter Paul Rubens, but such were "material treasures" as opposed to "Spiritual Treasures."[47] In other words, the antimaterialist quality of the artists' thinking spread to aesthetics.

Works of quality for the Blue Rider founders were possessed of Kandinsky's aforementioned notion of "inner necessity." In that spirit, Marc felt of his Germanness that he had "to represent what lives within me, the rhythm of my blood."[48] Moreover, he believed artists are the "interpreters and fulfillers of the will of the people;"[49] hence, the *Volk* tradition plays a role—that is, the heritage of the "common man" which was a touchstone of the period.[50] But the humble figure who was close to the soil existed side by side in Marc's mind with the notion of the artist as potentially an isolated martyr.

Critical to evincing the "will of the people," according to Marc, was the presence of a style with which to relate one's situation and faith. Marc and Kandinsky noted a unifying characteristic in their admired artistic models illustrated in the almanac, an "abstract" quality.[51] A key figure in the developing notion of abstraction was a friend of Kandinsky and Marc, Wilhelm Worringer,[52] author of a book published in 1908 entitled *Abstraction and Empathy*.[53] Worringer proposed that whereas naturalistic art was produced in cultures that were self-confident and comfortable in their surroundings, abstract art was the product of alienated, frightened peoples. Worringer likened widely disparate civilizations along these lines, much as Kandinsky and Marc found their heritage in diverse locales and synthesized these, through illustration, as if they were all part of one tendency.

When writing his treatise, Worringer related only models from history, not contemporary art. Abstraction meant representational detail summarized, briefly noted, or distorted. When Marc was writing, however, the term "abstraction" had a more current usage and had become the style required for him to express his inner necessity and reflect a consciousness of his culture. Nevertheless, his use of the term has a polarized ring, as if inspired by Worringer's thesis, and shows that Marc saw himself as part of an extensive line of abstract developments:

*I caught a strange thought… that people once before, a long time ago, like alter egos, loved abstractions as we do now. Many an object hidden away in our museums of anthropology looks at us with strangely disturbing eyes.*

*What made them possible, these products of a sheer will to abstraction? How can one think such abstract thoughts, without our modern methods of abstract thinking? Our European desire for abstract form is nothing other than the highly conscious, action-hungry determination to overcome sentimentality. But those early people loved abstractions before they had encountered sentimentality.*[54]

Marc wrote of "the deep inclination of the modern searcher to express something valid and unifying by means of the 'abstract'...."[55] According to him, various extraordinary achievements were possible with this means, including discovery and representation of the truth that lies beneath appearance. The resulting forms would, Marc claimed, evince the natural laws that concerned science, yet they would lead a separate artistic existence. Indeed, an "inner life" would be revealed.[56] One must understand, then, that abstraction, for Marc, was hardly concerned with style in a superficial sense.[57] Instead, as Kandinsky stated: "The pure form places itself at the disposal of the living content."[58]

Marc's ambition became the attainment of what he termed, in an essay in *Der Blaue Reiter*, *mystic-inner construction*. Subsuming a spiritual outlook, a firm basis in the surrounding culture, an intuitive method of seeing, and a freedom stylistically to render such feelings and insights, a *mystic-inner construction* was "the great problem of our generation."[59]

Abstract art even had the potential to offer absolution, according to Marc: "...I can in no other way overcome my imperfections and the imperfections of life than by translating the meaning of my existence into the spiritual, into that which is independent of the mortal body, that is, the abstract."[60] So all-encompassing was the new art that Marc wrote: "This art is our religion...our truth."[61]

At the time *Der Blaue Reiter* was published much of Marc's concern with abstraction had been spent in a search for symbols that would exist "on the altars of a future spiritual religion...."[62] By the time he wrote these words late in 1911 he had developed a set of representational symbols, such as the horse and cow. That these were arbitrarily colored and spiritualized in their depiction was a step toward abstraction; however, Marc's contact with Kandinsky and their joint missionary fervor for this style demanded something more of Marc in his art than he had developed thus far. Meanwhile, Kandinsky had already evolved a veiled iconography in which colors and abstract shapes could have great potential for meaning.[63] Thus, while *Der Blaue Reiter* to some extent represented a statement of where Marc had been, the real challenge for him was that his essays proposed a future course, one on which Kandinsky had already embarked.

The year 1912 became a crossroads for Marc, during which earlier tendencies remained in place until a new impetus emerged. Once again, the crucial stimulus came from France. Marc and August Macke visited Robert Delaunay in Paris, in September 1912. Delaunay had absorbed the flat abstract organization of Cubism, but in contrast had made color an important characteristic. Delaunay's synthesis was to have an even greater influence on the Blue Rider artists than the better known Cubists.[64]

An intimation of the influence of Delaunay on Marc can be found in *Three Horses* (pl. 25), *The Tiger* (pl. 37), *Deer in a Monastery Garden* (pl. 34), and *Rain* (pl. 35), all 1912. While earlier in the year

Marc had flattened his space in works such as *Two Horses*, 1911-12 (pl. 24), and *Dogs Playing*, 1912 (pl. 30), later in 1912 he further segmented space and rendered it with variously colored and shaped facets, as in *Three Horses*. Juxtaposed with the previously mentioned triangle-mountains are semi-circular, overlapping forms which are a quotation from Delaunay's work of the same year. Like the Frenchman, who was not always thoroughly abstract and would include favorite motifs, Marc filled his space with his usual animal theme. Curiously, Marc combines three horses with two black lines or tree trunks to total five elements in *Three Horses*, just as he adjusted the number of animals or lines to equal five also in *Yellow Cow, Blue Horses,* and *Dogs Playing*.[65]

While Marc's color symbolism may still theoretically be employed in works of late 1912, it has been significantly offset. Red, yellow, and blue are prominent, but secondary colors also abound as he echoes the kaleidoscopic approach of Delaunay. Nevertheless, the application of blue and purple to the triangular shape in *Three Horses* again asserts it as the spiritually striving form in the universe. Marc related the form, if not the color, to the body of a swine in *Pigs*, 1912 (pl. 29).

*Pigs* is a companion to Marc's *The Steer* of 1911 (pl. 18), for in both, the white animals are made into hulking triangular shapes, surrounded by spikey plants. White in Marc's work has been interpreted as symbolizing purity,[66] thus suggesting that *Pigs* is a kind of paradisiacal vision. As if to acknowledge the existence of opposites, much as the three primaries would be included in the same picture earlier, Marc sounds a powerful contrasting tone with the black orb that is completed on the pig itself. To make certain the shape is understood as celestial, it is echoed in the sky to the right. Behind the black form is the purple mountain-triangle. Thus, between the black note of destiny and the paradisiacal vision of white, stands the triangle of aspiration.

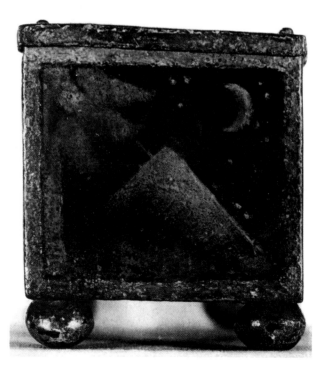

Fig. 11    Franz Marc, Painted Iron Chest, 1912
Private Collection, Munich

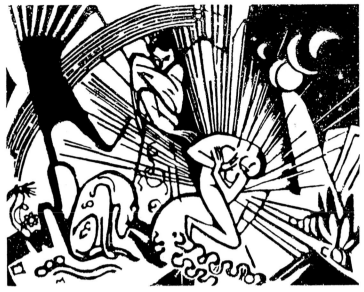

Fig. 12  Franz Marc, *Sleeping Shepherdess*, 1912
Städtische Galerie im Lenbachhaus, Munich

Fig. 13  Franz Marc, *Atonement*, 1912
Städtische Galerie im Lenbachhaus, Munich

Supporting the significance of the triangle in Marc's iconography is *Painted Iron Chest*, produced in 1912 (fig. 11), on which are several animal images, each a kind of archetype from Marc's repertoire. On one side is a mountain in the form of a perfectly drawn triangle, like a pyramid, shown in a night sky with a prominent quarter moon.[67] A number of illustrations in *Der Blaue Reiter* display the triangle prominently; it appears in Bavarian votive paintings, usually hovering and containing the image of the Virgin, and on one occasion framing the head of Christ.[68] A partial triangle, lacking the base, was used by Kandinsky to accompany the horse and rider in his cover designs for *Der Blaue Reiter*.[69] This pattern of parallel usage demonstrates the enormous significance of the form as a metaphor of aspiration for the authors. Moreover, Marc's use of a form sacredly employed by the admired Bavarian folk artists for his own beloved animals suggests the degree to which his subjects had become, for him, symbols of a new religion.

We have seen that during 1912 Marc's thematic concerns remained intact; however, he had begun to develop a more abstract vocabulary to state them. Abstraction and representation are blended in *Mountains (Rocky Way/Landscape)* (pl. 38). Starting in the lower sections, overlapping icy white, pyramidal shapes move toward the center and up. These forms are faceted in a Cubist manner but are not quite so flat. Atop the hill, in the upper right, is an isolated group of trees, reminiscent of scenes of German Romantic yearning.

Lankheit identified the subject of the paintings as the "Pioneer Path" in the Heimgarten and Herzogstand mountains, where Marc had hiked. According to Lankheit's interpretation, the rocky, difficult-to-climb road is a metaphor for the path of life,[70] much as Kandinsky's mountain motif is the usual backdrop for striving horsemen. Lankheit's interpretation confirms Marc's application of triangular forms to striving endeavors. As in the image of the mountain on the iron chest, a red sun stands at the top, perhaps as the heavenly goal of the yearning traveler on the "Pioneer Path."

Kandinsky had usually shown cities or towers atop hills, but Marc eliminates such references in *Rocky Way*. His move toward simplification of certain of Kandinsky's metaphors, while retaining essentially similar meaning, is seen elsewhere. For example, Kandinsky's apocalyptic trumpets may have been reduced to framing lines by Marc.[71] And whereas Kandinsky employed the horse and rider, Marc's horse alone stood for the aspirant to some heavenly place atop a mountain-triangle.

Marc briefly returned to figurative subjects in 1912 in a series of iconographically complex works. Sleep is an especially prominent theme, as in *Sleeping Shepherdess* (fig. 12) and *Antonement* (fig. 13), both of that year, and *Shepherds*, probably 1912 (pl. 23). In contrast to Hodler's *Night* (fig. 9), for example, sleep is not a time of nightmares for Marc. For him, in sleep is captured "the intimate reality of things, our dream life, the true life."[72] His sentiment suggests that an image of dreaming figures represents a paradisiacal scene of humanity. The celestial fantasy in *Antonement* supports such an interpretation. Related by gesture, or at times by color, animal and human spheres are empathetically united. Thus, in 1912 Marc proposes a positive future for humanity in keeping with the ideas and goals stated in *Der Blaue Reiter*.

The change in Marc's outlook coincided with the increasingly public role he played in the artistic life of his time. Besides helping to develop *Der Blaue Reiter*, he worked extensively to organize the two Blue Rider exhibitions. The first was held in December 1911, and the second early in 1912. The latter extended well beyond the original group to include, among others, the *Brücke* artists from Dresden (Nolde, Kirchner, Max Pechstein, Otto Mueller, and Erich Heckel), Swiss (Jean Arp and others), French (Picasso, Braque, Derain, and Vlaminck), and Russians (Natalya Gontcharova, Mikhail Larionov, and Casimir Malevich). By assuming a Pan-European approach, the Blue Rider founders represented in exhibition form the principal notion of *Der Blaue Reiter*: a united spiritual outlook.

Marc established strong ties with Herwarth Walden, publisher in Berlin of the periodical *Der Sturm*, and his circle, including the poet Else Lasker-Schüler (Walden's separated wife), with whom Marc collaborated, and Oskar Kokoschka. In Walden, he found a fellow propagandizer for the new spirit. Resuming an activity that had occupied him marginally in 1907 and 1908, Marc created a number of woodcuts for Walden's magazine, which were published from 1912 to 1915. In addition, he wrote several articles recording his reaction to various contemporary artistic events. For example, Walden had given considerable space to the writings of the Italian Futurists; he had also mounted an exhibition of that group. After initial ambivalence, Marc stoutly defended the movement in the pages of *Sturm* against the criticism it received.[73] In the process, Marc was perhaps influenced in his own feelings regarding contemporary life by the enthusiasm of the Futurists.

When a dispute arose over the selection of works for the Cologne Sonderbund exhibition, Marc became spokesman for the opposition in a *Sturm* article entitled "Ideas about the Nature of an Exhibition."[74] In it he wrote that "Artists are not dependent on exhibitions, but rather exhibitions depend totally on the artist."[75] Taking issue with Marc's view, heretical at that time, was Max Beckmann. Marc also encouraged Klee to translate Delaunay's important essay "On Light" and worked for its publication in *Der Sturm*.

# Innocence and Apocalypse (1913)

Dream and enchantment contrast with images of violence and apocalypse in Marc's paintings of 1913, as an amalgam of sentiments reflect the oncoming war. Perhaps the only thread that ties the opposing themes together is faith in destiny. Again, Marc used various stylistic modes to fit his subject matter.

*The Bewitched Mill*, 1913 (pl. 39), follows loosely a work of 1912 entitled *The Waterfall* (pl. 36). White water occupies a central place in both compositions and has the narrative effect of creating a dreamlike state. Humans come to the water to be touched by its power in *The Waterfall*, whereas in *The Bewitched Mill*, a cow, deer, and birds drink at the mill. The symbolic potential of water to cleanse, baptize, and purify links the two pictures to a common theme of enchantment and rebirth.[76]

The two pictures revise one's expectations of Marc's iconography in similar and significant ways. Humanity, shown either in its physical embodiment as a figure or by its environment, the city, is rather more blessed or pure than Marc had previously depicted. In *Waterfall*, the figures live a harmonious existence in nature; the human environment is so beneficent in *Bewitched Mill* that animals leave the wild to take sustenance in it. Perhaps Marc was influenced by Delaunay and the Futurists, all of whom valued modern life. Certainly, Marc's use of circular forms and urban subjects, which were previously absent in his work, recall Delaunay. Also, comparison of *Bewitched Mill* with Delaunay's *The Eiffel Tower* (fig. 14), reproduced in *Der Blaue Reiter*, is revealing. The central axis in each work is a white field of transformation: For Delaunay, the tower undergoes change within this field; for Marc, the white water causes bewitchment. In Marc's terms, a new Jerusalem and new human emerge from this purified situation. The revived emphasis on the human condition in *Waterfall* and *Bewitched Mill* indicates that Marc's view of life had evolved. At the same time, Marc began to see animals less heroically and more symbolically.

The animal group that symbolized innocence more than any other for Marc was the deer and related creatures. They assumed special prominence beginning in 1912, as Marc developed a set of prototypes to epitomize his conception of the world. He wrote: "It goes without saying that the animals also take part in this eternal cycle of types."[77] For Marc, the "types" interact in a preordained fashion:

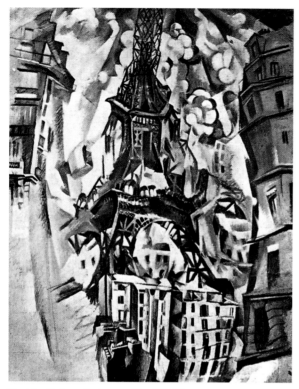

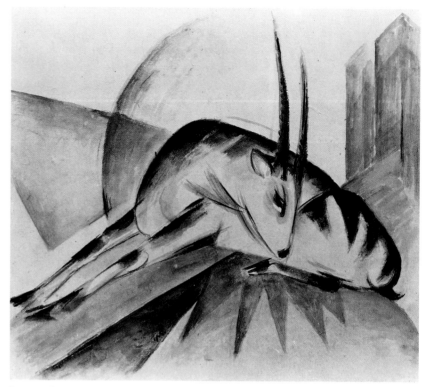

Fig. 14   Robert Delaunay, *The Eiffel Tower,* 1911
formerly Koehler Collection, Berlin, lost

Fig. 15   Franz Marc, *The Antelope (Gazelle),* 1912
Museum of Art, Rhode Island School of Design, Providence, R. I.

"True art forms are probably nothing other than this somnambulist seeing of the typical, the seeing of compelling (and therefore correct) relationships of tensions."[78] Thus, the character of one animal or another and their relationships in the world are predictable in Marc's iconography. For instance, deer, gazelles, and antelope are part of one genus in Marc's somnambulistically seen cast of characters.

Possessing a sweet character, the animals in *The Antelope (Gazelle),* 1912 (fig. 15), *Red Deer* (pl. 46), and *Sleeping Animals* (pl. 51), both 1913, also exhibit that chaste or "virginal" feeling Marc described as being expressible through certain creatures. Reposing on a pair of crossed diagonals, the form of the antelope is reflected in the composition by the repetition of spiked shapes and curves. Together, these force lines bring the animal into a dynamic relationship with nature. Once more in *Antelope,* like *Bewitched Mill,* nature and civilization are juxtaposed; the angular, planar buildings in the upper right are a sharp contrast to the rest of the watercolor.

Examples of deer abound in Marc's work, but in 1913 he generalized his renderings to produce *Seated Mythical Animal* (pl. 45). Still possessed of a kind of innocence, the animal is given a mythic identity by the title, subsuming the various gazelles, antelope, and deer. It is framed by the crossed diagonals at its feet and in front and in back of it, which are repeated in the ears and shoulder. Accompanying this rhythm is that of the mounds in the haunches, landscape, and head. Within the circle of the moon, a prominent crescent touches and dynamically reflects a second curve.

*Antelope* and *Seated Mythical Animal* show Marc monumentalizing the subject of the innocent creature, revealing it to be at peace with nature. Integrating the life of animals with nature by using

energy and force lines based on Futurism, Marc's goal was an overall harmony: "the organic rhythm that I feel is in all things...."[79] He wanted to penetrate appearance and depict an inner reality which in nature was epitomized by a rhythmic organization of phenomena. While similar compositions occur in the works of 1911, by 1913 a more complete fusion of animal with landscape is achieved.

A summation of the deer theme is *Deer in the Forest I*, 1913 (pl. 54). Amidst and integrated with the form of the deer is a panoply of force lines and transparent planes; an underlying organization of these exists in the pattern of parallel diagonals moving downward from the right and left edges, meeting in the middle. A secondary pattern exists in the rectilinear planes of color on the left opposing circular patterns on the right. While a blue mountain is absent, a smaller triangle encloses two of the deer; it and the blue tree at the left edge provide an uplifting quality. Contrasting the blue is the intense red throughout the center of the picture, oranges at top and bottom, and the feathery black in the upper right.

The all-over organization of the canvas, uniting animal to landscape, diminishes the heroism of the animal subject as depicted by Marc in 1911. Supporting Marc's latest conception of the world was, according to Lankheit, Wilhelm Ostwald's theory of energy, in which matter is considered illusory.[80] Only energy lines reveal appearance such as it is. In *Deer in the Forest*, this conception results in an energized atmosphere of randomness and chaos. The sense of an inchoate environment demonstrates both Marc's feeling of the world as a whole and his developing urge to represent Creation, an aspiration that is present in the work of Kandinsky and Klee as well.

Beyond the wish to evoke an idea of nature, Marc was interested in the deer as a symbol. In the context of his color equivalence system regarding red, the deer are utterly at peace with and at one with the earth. Lankheit appropriately notes that Marc wanted to create a "symbolic image" which has "moral significance."[81] In other words, the purity and innocence of the deer is meant as a reminder of how our own human nature diverges.

Above the perfect repose of the deer is a second symbolic animal, a bird hovering in the air. Its ascendant position and blue color suggest that it epitomizes a spiritual personage. Supporting that interpretation within Marc's iconography are kindred works in the pages of *Der Blaue Reiter*, including one in which a bird, personifying the Holy Ghost, flutters above the head of the Madonna in a Bavarian glass painting.[82] The caption which identifies the subject and which is part of the object was removed for reproduction in the yearbook, reflecting Kandinsky's and Marc's emphasis on the symbolic potential of narrative depictions. Another symbolic-looking bird appears in *Der Blaue Reiter* in Rousseau's *Portrait of Mlle. M.*; again, the creature is shown near the head of the stolid woman.[83] Marc's approximation of this device is in keeping with his efforts in *Der Blaue Reiter* to suggest spiritual kinships; now his picture joins the Bavarian work and French portrait through the presence of the bird in a similarly unexplained appearance. Beyond the visual likeness is the potential thematic relationship, for in the glass painting, the arrival of the heavenly creature signals a moment of divine peace. In *Deer in the Forest*, the deer, an evocation of pure earthliness, is joined by the heavenly personage of the bird to produce an image of profound calm and symbolic wholeness.

While the deer was portrayed in a relatively consistent manner as a "type" in Marc's reper-toire, the horse was more flexibly employed in 1913.[84] A completely heroic animal in 1911, in 1913 several factors seemed to alter this characterization on occasion. The oncoming war, together with Marc's identification with the horse, caused the animal to be seen in a range of emotional states that reflect the fluctuating moods of a particularly ominous period. Yet another influence—his reading of Count Leo Tolstoy—may have played a part too in Marc's diminishment of his 1911 heroic horse. On a minor drawing of a horse in 1913, Marc records the title of a Tolstoy short story, *Der Leinwandmesser* ("The Linen-Measurer").[85] The writer assumes the voice of a pathetic, ugly horse who is constantly abused by other animals and his various owners. Tolstoy empathizes with the horse, anthropomorphiz-ing its emotions and interactions. His tragic portrayal was repeated on occasion by Marc in 1913.[86]

The horse is shown in a variety of symbolic attitudes through 1913, including head bowed as if in prayer or head pointed up toward mountainous peaks and heavenly orbs, as in *Two Blue Horses*, 1913 (pl. 43). In *Two Horses Red and Blue*, 1912 (pl. 26), the animals are both fully united with their environ-ment, yet the attitudes differ. While in repose, the gesture of the blue one seems to be more outward reaching as opposed to the inner peace of the red horse. As with the deer, seen earlier, the attribute of red in a horse signals integration with nature; indeed, the red horse is under the domination of the sun. The blue, spiritual horse is rather more lost in thought, suggesting again concordance with Expressionist pathos and the conception of the artist as ever-yearning.

The noble rendering of mountain and horse in *Two Blue Horses* predicts the precious yet magnificent *Colorful Flowers* of 1913-14 (pl. 44), in which a similar group of peaks are in array. In this work, too, the mountains represent a romantic pinnacle to the composition. Just as the curvilinearity of the horses contrasts with the angularity of the mountains in *Two Blue Horses*, Delaunay-like curves are juxtaposed with the peaks in the later work.

A lost work by Marc entitled *Tower of the Blue Horses*, 1913 (fig. 16), must be mentioned in relation to *Two Horses Red and Blue* and *Two Blue Horses*, for the latter pair appear to be studies or intimations of the former painting. *Tower* has been interpreted as showing blue horses longing for union with a blue sky, and as an image of salvation.[87] In contrast to the works of 1911, the animals, again heroic, are stacked vertically in this picture. Faced forward, the horses recall *Blue Horse with Rainbow (Blue Horse in Landscape)*, 1913 (fig. 17), in which a second iconographic similarity exists—the presence of a rainbow.

The rainbow has been variously interpreted. It has been called a sacred altar symbol[88] and an apocalyptic motif,[89] yet these definitions are but part of the explanation. The rainbow appears fre-quently in Marc's work (see also *Painting with Cattle*, 1913, pl. 40). On many occasions, it encircles and protects,[90] much as the sun seems to confer great domestic placidity in a Russian Folk print illustrated in *Der Blaue Reiter*.[91] The stunning and welcome occurrence of a rainbow is like that of the Holy Ghost appearing in the guise of a bird, or the arrival of a dove on Noah's ark following the Flood. A rainbow also appears after the Flood to symbolize reconciliation or pardon given by God to humanity.[92] These situations are sought after and provide an immense sense of spiritual well-being. Thus, the presence of a

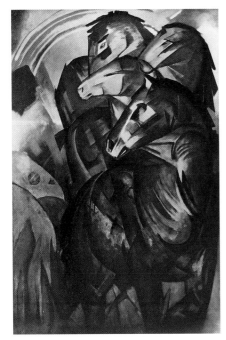

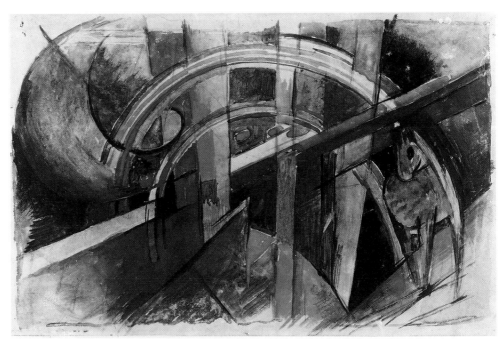

Fig. 16   Franz Marc,
*Tower of the Blue Horses,* 1913, formerly
Nationalgalerie, Berlin, lost

Fig. 17   Franz Marc, *Blue Horse with Rainbow,* 1913
Philadelphia Museum of Art, Philadelphia, A. E. Gallatin Collection

rainbow implies *rapprochement* between heavenly and earthly creatures. On one occasion, *Landscape with Animals and Rainbow,* 1911,[93] the rainbow appears above a stack of triangular notations of mountains, with a group of horses at the foot of this overly vertical format. In its format and juxtapositions, this work dramatically prefigures *Tower,* and creates an important identification in Marc's iconography between the striving mountain and the aspiring horse. Reinforcing the interpretation of the rainbow as a *rapprochement* is the synthesis of a semi-circle and half-triangle at the lower edge of *Blue Horse with Rainbow.*[94]

Finally, the life of the horse assumes an utterly human and tender tone amidst a Futurist composition in *Horse Asleep,* 1913 (pl. 42). The picture seems a powerful *denouement* to the Hans Baldung Grien woodcut, reproduced in *Der Blaue Reiter,* depicting the combat of stallions.[95] Transposing the aggressive biting gesture of the earlier work to one of nuzzling concern, Marc imparts a similar sense of death about the animal in the foreground. He was later to write of seeing a horse in its death throes: "a proper Pegasus" which "sighed like a human."[96]

More tragic yet is *The Unfortunate Land of Tirol,* 1913 (pl. 57), a work in which is collected Marc's now-familiar motifs in a pregnant moment preceding the all-out conflagration of war. The background is divided into three sections, two of which are large mountains; the third is dominated by the parallel rhythm of the rainbow and a branch, on which a bird sits. A cemetery and ramshackle building occupy the middleground; in the foreground is an Austro-Hungarian border sign[97] and a pair of pathetic-looking horses, a sharp contrast to the *Red Horses.* The painting is composed largely of blacks, purples, and greens, with a few touches of red and a hint of some blue peaks in the distance. The

presence of so much purple, according to Marc, produces "unbearable sadness, and comforting yellow, the complementary of violet, becomes indispensable."[98] Yet Marc's vision in *The Unfortunate Land of Tirol* is so single-minded that the yellow is absent.

The painting clearly reflects the Balkan war and Tirolean vulnerability, as Angelica Rudenstine aptly notes.[99] Lankheit states the painting was done in May 1913,[100] which would date it about a month before the declaration of war. About another premonition of World War I, *Fate of the Animals*, 1913 (pl. 55), Marc wrote: "It is artistically logical to paint such pictures *before* wars, not as dumb reminiscences afterwards. For then, we must paint constructive pictures indicative of the future...."[101] Yet Marc clearly wanted the war: "I ... see in this war the healing, if also gruesome, path to our goals; it will purify Europe, and make it ready... Europe is doing the same things to her body France did to hers during the Revolution."[102] Marc's plea for the apocalyptic conflagration is in accord with Kandinsky and reflects a desire to obliterate what they saw as their materialistic and degraded culture in order to bring about a return to innocence and purity. Writing in 1914 at the front, Marc said: "The war was nothing if not a moral experience... a preparation for a breakthrough to a higher spiritual existence; just the kind of event that was needed for sweeping the dirt and decay away to give us the future today."[103] Marc expected that the war would destroy the "invisible enemy of European spirituality."[104] Thus, in keeping with his Expressionist outlook, Marc saw himself achieving redemption through suffering.

Where, then, is the redemption in *The Unfortunate Land of Tirol*? Earlier interpretations have provided no escape from the pathos. The horses are certainly the most pathetic yet seen in Marc's work. However, a painting of the same year, *Long Yellow Horse* (pl. 53), reveals a similarly awkward creature standing in a mountain setting but with a rainbow. Marc wrote in 1915 of the point at which animals became ugly for him: "Trees, flowers, the earth all showed me every year more and more of their deformity and repulsiveness...."[105] Yet, while ugly, this horse has been monumentalized by the rainbow. Moreover, it is naturalistically far too large for its situation, giving it an iconic quality. Similarly, Tolstoy's "Linen-Measurer" is characterized as ugly and pathetic, yet simultaneously noble and aristocratic: "Like a living ruin, he stood alone in a dew-drenched meadow...."[106] Tolstoy's gelding is worthy of our utmost admiration due to its philosophical resolution of the many trials in its life. Perhaps Marc's awkward horse is a new symbol for his vision of life following the war. It becomes Marc's reevaluation of his own favorite motif.

As was seen earlier in *The Bewitched Mill* and *Deer in the Forest*, birds represent a certain buoyant vitality. The bird in *The Unfortunate Land of Tirol* has been interpreted as Germany, standing above its border and symbolizing a hoped-for unification.[107] It has also been construed as an apocalyptic scavenger.[108] But the bird is an eagle, symbol of Resurrection.[109] An anecdote regarding a wartime visit to Münster in 1915 suggests Marc interpreted birds in a generally similar light: "I suddenly saw a little bird sitting on a ledge and had the feeling as if the bird were the only living thing, the only artless reality in a dead city in which only corpses move.... It didn't make me at all melancholy,—art is not touched by this death."[110] Perhaps Marc's story reflects on his symbolism in *The Unfortunate Land of Tirol*. If, as the earlier cited comments indicate, Marc saw hope emerging from the conflagration, his animals,

however ugly, would be the one symbol to reveal that hope. Placement of the bird by the rainbow, like the horses in *Tower* and *Blue Horse and Rainbow* and the figure and dog in *Atonement*, then signifies spiritual victory following the apocalypse.

In this new spirit with regard to the ugliness of animals, Marc turned in 1913 to a subject in which the horse became an accomplice in an act of destruction. The tempera (pl. 52) is based on Marc's reading of a novella by Flaubert, *La Légende de St. Julien l'Hospitalier*, noted on the upper left of the sheet. Julian was a knight who, in the heat of a hunt, became crazed, killed numerous animals and, unknown to him, his parents. Contributing to the destructive character of the scene is the group of tree trunks, grim reapers that occur frequently in 1913 in apocalyptic contexts.[111] Marc reveals the deer and pig cringing beneath the horse's hooves, as symbols of the innocence that is destroyed. According to the story, Julian managed to achieve union with his Lord after a period of repentance. Marc, in keeping with his feelings regarding the war, chooses as his vehicle a tale of destruction from which redemption is, nonetheless, possible.

Not only had Marc employed the horse for destruction, it was his and Kandinsky's own logo, a "blue rider," who carried out the event on the red earth with no comforting yellow. Thus, Marc's wish for an apocalypse had taken such enthusiasm that he himself became responsible for the massacre of his own favorite symbols of innocence. Reinforcing the significance of Marc's remarkable reversal is an illustration in *Der Blaue Reiter*. A Bavarian mirror painting on the frontispiece showing the charitable St. Martin on horseback and a beggar faces the words "Der Blaue Reiter." With *St. Julian*, the character of the blue rider has taken an altogether bloody and tragic turn.

Marc continued in 1913 to show other predators and scavenging animals, as in, for example, *The Wolves (Balkan War)* (pl. 59). In an unusually horizontal, earthly format, Marc depicts a group of blue-back, red, and brown wolves in an exceedingly shallow space, moving in a wave from right to left. The flattened, angular animals closely resemble Futurist planes; triangular shapes frame them at bottom and at top, while circular forms are placed in the upper left. A kind of chaos prevails in which free-floating spots of color, linear planes, and shapes residing on the pictorial surface overlap and intermesh. This tension between surface and space recalls Fernand Léger, as did the columnar forms in *St. Julian*.

Bent on destruction, the wolves represent the most barbaric and savage forces of the war. Their willingness to eat the flesh of the dead makes them especially fearful symbols. That Marc seeks so immediate an image possibly again reflects his reading of Tolstoy, specifically the essay "What Is Art?"[112] In it, the Russian writes that art consists of compelling the viewer to feel what the narrator had experienced. Tolstoy, whom Marc discussed often in his letters,[113] specifically mentions as an example a boy's attempt to relate a fearful experience he has had with a wolf.[114]

For Marc, whose deep feeling for animals and nature was so much a part of his spirit, to formulate images of such savagery is but part of his turn from a pantheistic outlook. Perhaps, because of his deluded notions regarding the war, he had in 1913 resigned himself of his noble ideal regarding animals, to use them only as symbols. His cooling passion was accompanied by a deepening commitment to abstraction.

# Abstraction (1913-1916)

By late in 1913 Marc was increasingly organizing his vision with an abstract vocabulary. A language largely evolved from Kandinsky, Delaunay, and Futurism, as well as Macke's color compositions of 1912, this abstract mode unified his subject matter while reducing the melodrama. Abstraction, in Marc's view, became a means of expressing the existence of one creative law of the universe. Hence, the horse is no longer shown in individual terms of heroism or pathos but rather as an aspect within a universal field of forces. That field, whether determined by a generative or destructive law or by an overall "structure of the universe,"[115] occupied Marc in his final paintings.

*Stables*, 1913 (pl. 56), the last major work based on the horse theme, aptly demonstrates Marc's late approach to his favorite subject. He no longer shows the world in representational terms or as seen from an individual animal's vantage point. Rather, an overall pictorial structure of large diagonal crosses holds within it a group of red, blue, and white horses. Opposed to earlier gatherings, the animals in *Stables* have a more rigid and schematic portrayal. The circular and semi-circular body parts form a rhythm across the surface which is contrasted with the angular lines of the stable structure.

*Stables* especially recalls Delaunay's *Windows*, 1912 (fig. 18), because of its horizontal format, triangular shapes, and evanescent, shifting color planes that carry the eye across the surface of the picture. Marc's color, however, is far more intense and strident than Delaunay's, as primaries predominate. While similarly Cubist in orientation, the space in Marc's painting is not quite so airy yet flat as Delaunay's; it is denser and more tangible. The blue vertical bar at the right edge and the yellow diagonals establish the surface, but Marc's treatment of the animals creates a slight, shallow space.

The device in Delaunay of a universal flux pervading whatever subject is treated led Marc away from his more symbolic approach. No longer indicative of what man is not, or even projections of humanity, the horses become simply a motif. Marc showed them within a barn in order to utilize the structural attributes of the building, as opposed to representing their great naturalness. Now nature, seen as a continuously undulating surface of matter, subsuming everything, is Marc's subject and concern. In that spirit, a frequent theme or allusion in 1914 was Creation.

It has been suggested that Marc's subject matter evolved programmatically in 1913 and 1914 from images of apocalyptic premonition, to apocalypse itself, and finally to works that indicate a new

beginning.[116] This development accords with the artist's previously cited comment that, during the war, a constructive approach was necessary. One vehicle toward that positive goal was a project in which Marc was to collaborate with Klee, Kokoschka, Alfred Kubin, and Heckel on a series based on the Bible.[117] Marc's contribution to the never-completed series was prints on the theme of Creation. Wanting to depict the moment that various species emerged from chaos, that is, the origin of the animals, Marc showed horses in the magnificent *Birth of the Horses*, 1913 (pl. 41), an archetypal monkey in *Creation I* (fig. 19), and a snake in *Creation II* (fig. 20), both 1914. Through abstraction, Marc structurally united animals and landscape to produce an overall unity suggestive of the flux of nature itself.

Frequently in 1914 Marc presents vibrant formal relationships that epitomize the most extreme moments in nature. For example, in *Fighting Forms*, 1914 (pl. 63), he dramatically depicts red and blue areas in conflict; in *Animals in Landscape (Painting with Bulls II)*, 1914 (pl. 65), he created a similar aura of intense energy, with raging linear, coloristic, and planar juxtapositions, characteristic of Marc's finest work of 1914. Both creation and apocalypse assume similar appearance for Marc, as the visual attributes of *Painting with Bulls*, which is without clear suggestions of conflagration, appear, also, in *Fate of the Animals*. Thus, Marc's aim in 1914 is to show a singular red-versus-blue relationship underlying all events, like a law of nature. This contrast was the dominant one in *Blue Horses* of three years earlier. But whereas in that work a heroic portrayal ensued, in 1914 Marc had abstracted the conflict.

Curiously, Marc has employed in the upper right of *Painting with Bulls* the black shape seen earlier as a tree or as a framing element in such works as *The Waterfall*. This same shape again plays a prominent framing role in *Broken Forms*, 1914 (pl. 64), surrounding a blue element. One interpretation of *Broken Forms* states the painting has no relationship to objects;[118] however, another suggests a transformation of a house and garden motif.[119] The second view is probably closer to the truth in general terms, given Marc's method and other precedents.

Fig. 18   Robert Delaunay, *Windows*, 1912, The Museum of Modern Art, New York, John S. Newberry Collection

We have seen that Marc's career in part consisted of metamorphosing themes he had already considered, as in the case of his treatment of human figures and animals, and the absorption of human qualities into the animals. In a formal transformation, he turned the previously discussed *Colorful Flowers* 90 degrees counterclockwise to create a new composition.[120] Similarly, *Fighting Forms* seems a formal and perhaps thematic metamorphosis of the work of 1911 entitled *Fighting Cows.*

In 1913 Marc had begun the process of fragmentation concluded in *Broken Forms.* Simultaneous with *Stables*, he produced a very similar work entitled *Bull (Painting with Bulls I)*, 1913, in which parts of the animal, such as the head and shoulders and the eye, are isolated. *Broken Forms* seems the conclusion of this development. The blue shape within the black curve in the upper right, and the orange form to the right of the black line in the lower center, appear to be the nostrils of animals, if compared to *Blue Horses, Pigs, Painting with Bulls,* or *The Steer*, in all of which the nostrils are quite prominent. The presence of the blue verticals, seen in *Stables*, suggests the original motif of *Broken Forms* may even have been cows in a stable. Reinforcing the air of metamorphosis in *Broken Forms* is the central, white area, which appeared in earlier scenes of change, including *The Waterfall* and *The Bewitched Mill.*

Marc's conclusion that animals, like humans, were ugly became an important motivation for his concentration on nostrils. In emphasizing snouts, he chose one of the least attractive attributes of animals, as if to turn himself from his fascination with their dynamic, physical character to an aspect of no inherent beauty or interest.

"There is only one blessing and redemption: death, the destruction of the form, which liberates the form, which liberates the soul.... Death leads us back into normal being."[121] Turning to animal fragments is in keeping with the "destruction of the form" (read "appearance"). In *Broken Forms*, Marc has pictorialized the action, quoted above, in order to arrive at some kind of liberation. In his terms, "normal being" can mean a reappraisal of the human situation following the apocalyptic war and its destruction. Beyond the animals, then, is art, a humanly achieved force with the potential powers of extraterrestrial insight.

*Broken Forms* is an example of Marc's final series of works, a group from 1914 with titles such as *Playing Forms, Abstract Forms, Fighting Forms, Higher Forms*, and *Small Composition I, II* (pl. 61), *III* (pl. 62), and *IV.* In these, Marc has taken the step to virtual abstraction, a move he had continuously approached. Apparently, as with the earliest horse paintings, Marc was somewhat dissatisfied with these works, however, and, calling them experiments, he preferred not to exhibit them.

In the spring of 1914 Franz and Maria Marc bought a small country house in Ried, near Kochel am See in Upper Bavaria. According to Kandinsky, this purchase was one of "Marc's greatest wishes come true."[122] He was even able to keep a dog and a tame deer there.[123] But in August of 1914, at the outbreak of the war, Marc volunteered. Kandinsky visited him to say "Auf Wiedersehen," but Marc replied "Adieu." He said "...I know we shall not see each other again."[124] Within two months, Marc's first personal indication of the war's magnitude occurred; August Macke died in battle in September at the age of twenty-seven.

Fig. 19    Franz Marc, *Creation I*, 1914, Städtische Galerie im Lenbachhaus, Munich

Fig. 20    Franz Marc, *Creation II*, 1914, Städtische Galerie im Lenbachhaus, Munich

40

Marc wrote and drew extensively at the front. His drawings show a remarkable looseness and facility, for the most part combining figurative elements within a Cubist or Futurist framework of lines. While not from that series, *Mountain Goats*, 1914 (pl. 60), gives a good sense of the style of the war drawings. Frequently still, innocent animals are depicted, yet now within a gradually tightening web of force lines that are reminiscent of Marc's visions of destruction, *Fate of the Animals*, 1913, or *The Birds*, 1914 (pl. 66).

While cataclysmic events occurred around him, Marc nevertheless theorized on the supposed benefits of war, including the thought of a spiritual breakthrough and redemption through suffering. He was so moral in his belief in the eventual beneficent effects of the war that he could ignore the fact that patriotic allegiances fueled the war and caused his presence. "I'd rather be a good European than a German."[125] Finally, he interpreted events in a more fatalistic way. Like the animals who had become simply motifs in a larger scheme, he saw himself at war in similar terms. The conflicts in Marc were mirrored on his exterior according to Klee, who wrote following a visit in 1915:

*The continuous pressure and loss of freedom clearly weighed on him. I now began really to hate the cursed costume. The fellow ought to paint him again, then his quiet smile would appear.... He is much too far along for the burning ferment he is in. It occurs because his vent is not allowed to function.*[126]

In the war Marc was forced to rationalize his aims, but the conflicts and questions that resulted disturbed him profoundly. Klee was "afraid that he might be a completely different man some day,"[127] as if his delicate balance might not withstand reality. The trauma of the war for Marc was such that, at the end, only death could give him relief. In that state his own innocence could be restored. One of Marc's last letters, before his death at Verdun in 1916, concluded on this note:

*I understand well that you speak as easily of death as of something which doesn't frighten you. I feel precisely the same. In this war, you can try it out on yourself—an opportunity life seldom offers one.... nothing is more calming than the prospect of the peace of death.... the one thing common to all. [it] leads us back into normal "being." The space between birth and death is an exception, in which there is much to fear and suffer. The only true, constant, philosophical comfort is the awareness that this exceptional condition will pass and that "I-conciousness" which is always restless, always piquant, in all seriousness inaccessible, will again sink back into its wonderful peace before birth... whoever strives for purity and knowledge, to him death always comes as a savior.*[128]

# Conclusion

Franz Marc contributed to the vision of abstraction in its second wave, 1911-14, by wedding an Expressionistic outlook to the new pictorial developments emanating from France. There, formal innovations were largely an end in themselves. But in the hands of Marc and Kandinsky, arbitrary color, faceted planes, and pictorial structure became modes with which certain deeply held themes could be stated. Marc's achievement was in effect creating works of art that, through abstract means, evinced his conception of the overall unity and character of nature.

As a founder of the Blue Rider, Marc holds a place in the theoretical impact of this pivotal movement on future developments, such as Dada and Bauhaus. More specifically, Marc was to have an influence on his colleague Paul Klee. The latter described their relationship as a pair of overlapping circles, with a "relatively large common area."[129] Although a year younger, Marc reached artistic maturity ahead of Klee. In general, the overall delicacy of touch and transparency in Marc's watercolors are close to the work of Klee after 1914. Also, certain motifs appear first in Marc's work and subsequently in Klee's; for example, Marc's use of triangles and upward-moving forms to imply aspiration became a constant in Klee's art. Marc's depiction of the buildings in *Antelope*, 1912, anticipated Klee; the arrowlike trees in *Red Deer*, 1913, predicted many works of Klee; and Klee was to concentrate considerable attention on lonely mountain peaks similar to Marc's emphasis in *Colorful Flowers*, 1913-14. The two shared much in common theoretically, especially the desire to see through appearance to inner truth. But Marc looked to his earthly situation for subjects, whereas Klee sought a transcendent vantage point. Reinforcing their common belief in fate was the fact that, on the day Klee received word from Maria Marc of his friend's death, he was drafted.[130]

The desire by the German wave of abstractionists to unite the new pictorial means from France with ambitious or transcendent subject matter, or both, quickly became the goal of subsequent movements of twentieth-century abstraction. While Marc was not alone in possessing lofty aspirations, he and Kandinsky established a critically important step in making Cubist and *Fauvist* harmonies apply to an elevated concept of subject matter. For instance, the desire for content of epic proportions became a touchstone in the work of Malevich and Piet Mondrian, and then, among American Abstract-Expressionists Jackson Pollock, Barnett Newman, and Mark Rothko.

Fortunately, Marc managed, before death cut his life short, to express fully his passionate and sensuous outlook in a burst of beautiful works within a brief three-year period. One wonders about figures such as Marc whether their ardor somehow foreshadows their demise. Van Gogh, as well as Runge, also died about the same age as Marc,[131] and many of the Expressionists suffered mental disorders that abbreviated the period of their major production. Marc is part of a line of artists, stretching from van Gogh to Rothko, who treat style as philosophy and art as ecstasy. Their impact on subsequent artists is not so much formal as by example.

Figs. 21/22   Franz Marc, Battlefield sketchbook, 1916, 36 drawings; they are the last known works of the artist.
Left: 3. "A lot of light green with red tips, plant life in the making." – Right: 9. "Very colorful." Staatliche Graphische Sammlung, Munich

# Notes

1. Franz Marc. *Briefe 1914-1916 Aus dem Felde* (Berlin, 1959), p. 89.
2. Alois J. Schardt, *Franz Marc* (Berlin, 1936), p. 12.
3. Schardt, *op. cit.*, pp. 10-11; also Klaus Lankheit, *Watercolors-Drawing-Writings* (New York, 1960), pp. 12-13.
4. Marc, *op. cit.*, p. 82, letter of June 23, 1915.
5. Schardt, *op. cit.*, p. 40.
6. Quoted in Lankheit, *op. cit.*, p. 14.
7. *Ibid.*, p. 14.
8. Marion Wolf ("Biblia Omnii: Timeliness and Timelessness in the Work of Franz Marc," *Art Journal*, vol. XXXIII, no. 3 [Spring, 1974], p. 227) discusses the increasing significance of zoos in this period as a factor in Marc's turn to animal subjects.
9. Klaus Lankheit, *Franz Marc: Katalog der Werke* (Cologne, 1970), No. 889, 331, 277, 377, 874 respectively. Subsequent references to works illustrated in this volume will be indicated with "K" followed by the catalogue number.
10. Quoted in Herschel B. Chipp, *Theories of Modern Art* (Berkeley and Los Angeles, 1968), p. 182.
11. Quoted in Wolf, *op. cit.*, p. 226.
12. Schardt, *op. cit.*, pp. 55-57.
13. *August Macke – Franz Marc. Briefwechsel*, edited by Wolfgang Macke (Cologne, 1964), p. 23.
14. Marc, *op. cit.*, p. 28.
15. Quoted in Wolf, *op. cit.*, p. 227.
16. Klaus Lankheit, *Franz Marc: Sein Leben und Seine Kunst* (Cologne, 1976), p. 52.
17. *Macke and Marc, op. cit.*, p. 28; also Lankheit (*Watercolors-Drawings-Writings*), *op. cit.*, p. 16.
18. Quoted *ibid.*, p. 17, letter of January 31, 1911.
19. *Macke and Marc, op. cit.*, p. 28.
20. K 129.
21. The pose of the contemplative horse was a favorite of Marc's which he repeated in images of a single horse in 1910 and 1911. (See K 130 and K 137).
22. Franz Marc, *Briefe, Aufzeichnungen und Aphorismen*, 2 vols. (Berlin, 1920), vol. 1, pp. 121-22.
23. Robert Goldwater, *Primitivism in Modern Art* (New York, 1938), p. 136.
24. Compare Henri Matisse, *Landscape at Collioure*, 1908 (Gelman Collection), or André Derain, *Trees*, 1904, to Marc's *Weasels at Play*, 1911.
25. Macke and Marc, *op. cit.*, p. 40.
26. Quoted in Sixten Ringbom, "Art in 'The Epoch of The Great Spiritual,'" *Journal of the Warburg and Courtauld Institutes* (1966), p. 391.
27. Frederick Spencer Levine, *The Apocalyptic Vision: An Analysis of the Art of Franz Marc within the Context of German Expressionism* (dissertation) (St. Louis: F.S. Levine, Washington University, Xerox, University Microfilms, Ann Arbor, Michigan 48106, 1975), p. 108.

28. Lankheit (*Watercolors-Drawings-Writings*), *op. cit.*, p. 20.
29. Hutton-Hutschnecker Gallery, *Kandinsky, Franz Marc, August Macke: Drawings and Watercolors* (New York, 1969), p. 80, letter to Piper, December 1908.
30. Wassily Kandinsky, *Concerning the Spiritual in Art* (New York, 1947), pp. 27-30.
31. In *First Animals* by Marc, 1913, he also places a triangle next to his "M".
32. Paul Overy, *Kandinsky: The Language of the Eye* (London, 1969), p. 175.
33. Kandinsky, *op. cit.*, p. 29.
34. Quoted in Hutton-Hutschnecker, *op. cit.*, p. v.
35. Mark Rosenthal, *Paul Klee and the Arrow* (unpublished dissertation), University of Iowa, 1979.
36. Macke and Marc, *op. cit.*, p. 28.
37. Rose-Carol Washton Long, "Kandinsky and Abstraction: The Role of the Hidden Image," *Art Forum* (June 1972), p. 43.
38. Quoted in Hutton-Hutschnecker, *op. cit.*, p. viii.
39. *Ibid.*, p. 73.
40. Hutton-Hutschnecker, *op. cit.*, p. ix.
41. Wassily Kandinsky and Franz Marc, *The Blaue Reiter Almanac*, ed. Klaus Lankheit (New York, 1974), pp. 92-96.
42. *Ibid.*
43. *Ibid.*, p. 65.
44. Quoted in Hutton-Hutschnecker, *op. cit.*, p. 48, Aphorism no. 39, from *Letters, Notes and Aphorisms* (Berlin, 1920).
45. Lankheit (*The Blaue Reiter Almanac*), *op. cit.*, p. 61.
46. Victor H. Miesel, *Voices of German Expressionism* (New Jersey, 1970), p. 67, quoting letter to Macke, January 14, 1911.
47. Lankheit (*The Blaue Reiter Almanac*) *op. cit.*, pp. 56 and 59, "Spiritual Treasures" by Marc.
48. Macke and Marc, *op. cit.*, p. 184-84.
49. Quoted in Goldwater, *op. cit.*, p. 135.
50. George L. Mosse, *The Crisis of German Ideology* (New York, 1964), p. 52.
51. Marc (*Briefe*), *op. cit.*, pp. 69-70.
52. Lankheit (*The Blaue Reiter Almanac*), *op. cit.*, p. 30.
53. Wilhelm Worringer, *Abstraktion und Einfühlung* (Munich, 1959).
54. Quoted in Chipp, *op. cit.*, p. 181, Aphorism no. 87.
55. Marc (*Briefe*), *op. cit.*, pp. 67-70.
56. Lankheit (*Watercolors-Drawings-Writings*), *op. cit.*, p. 7, quoting "Constructive Ideas in the New Art."
57. Hutton-Hutschnecker, *op. cit.*, p. 72, quoting letter to Koehler, April 24, 1915.
58. Quoted in Overy, *op. cit.*, p. 65.
59. Lankheit (*The Blaue Reiter Almanac*), *op. cit.*, p. 59.
60. Marc (*Briefe*), *op. cit.*, p. 119.

61. Chipp, *op. cit.*, p. 180, Aphorism no. 35; see also Hutton-Hutschnecker, *op. cit.*, p. 56, Aphorism no. 35; Lankheit (*Watercolors-Drawings-Writings*), *op. cit.*, p. 7, quoting "Constructive Ideas in the New Art."

62. Lankheit (*The Blaue Reiter Almanac*), *op. cit.*, p. 64.

63. Washton Long, *op. cit.*, p. 42.

64. Peter Selz, "The Influence of Cubism and Orphism on the 'Blue Rider,'" in *Festschrift Ulrich Middeldorf*, ed. Antje Kosegarten, Peter Tigler (Berlin, 1968), pp. 582-90; also Herschel B. Chipp, "Orphism and Color Theory," *The Art Bulletin*, 40 (March 1958), p. 62.

65. One might speculate on Marc's use of the number five because of his inclination to use a color symbolism and his colleague Kandinsky's arcane use of three horsemen of the apocalypse. For instance, five symbolizes the pentangle, a magic symbol in Marc's beloved medieval sources. See, for example, *Sir Gawain and the Green Knight*, introduction by Jessie L. Weston (New York, 1970). This symbolism is discussed by Vincent Foster Hopper, *Medieval Symbolism* (New York, 1938), pp. 124-25. (I am grateful to Ruth Melinkoff for informing me of the pentangle symbol.) Also, five trumpeters, instead of the conventional seven, appear in a biblical illustration, *Jews with the Ark of the Covenant at the Walls of Jericho from the Lübecker Bible*, illustrated in Lankheit (*The Blaue Reiter Almanac*), *op. cit.*, p. 210.

   The trumpets in the Lübecker Bible frame the covenant much as the heavy lines encircle the animals. In both, a similar compositional device helps monumentalize the corresponding vehicles of a new religion. Given Marc's belief that his pictures and the subjects represented in them were symbols of an ascendant faith, perhaps his numerology is meant to veil an association related to the founding of a new covenant. Certainly the moment of victory by spiritual forces in the Lübecker illustration would have had great meaning to Marc and Kandinsky, who both sought regeneration of spirituality after a period of moral corruption. Trumpets commonly appeared in Kandinsky's work as well, often framing scenes having to do with the Last Judgment and Resurrection and in conjunction with toppling towers. Thus, while Kandinsky looks to the New Testament and Marc to the Old, they both employ a similar motif to give meaning to scenes that have virtually the same meaning.

66. Lankheit (*Sein Leben und Seine Kunst*), *op. cit.*, p. 77; Schardt, *op. cit.*, p. 87.

67. Compare Klee's *Niesen*, 1915 (Kunstmuseum, Bern).

68. Lankheit (*The Blaue Reiter Almanac*), *op. cit.*, pp. 148, 160-63, 205.

69. *Ibid.*, pp. 254-55.

70. Lankheit (*Sein Leben und Seine Kunst*), *op. cit.*, p. 115.

71. See note 65.

72. Marc (*Briefe*), *op. cit.*, p. 53.

73. Franz Marc, "Die Futuristen," *Der Sturm*, 3 (1912), p. 187; and "Die Futuristen Literatur," *Der Sturm*, 3 (1912), p. 194.

74. Franz Marc, "Ideen über Ausstellungswesen," *Der Sturm*, 3 (1912), pp. 152-55.

75. *Ibid.*

76. Compare *Vögel*, 1914, K 226, and *Im Regen*, 1913, K 192.

77. Marc (*Briefe*), *op. cit.*, p. 53.

78. *Ibid.*

79. Quoted in Peter Selz, *German Expressionist Painting* (Berkeley and Los Angeles, 1957), p. 201.

80. Lankheit (*Watercolors-Drawings-Writings*), *op. cit.*, p. 17.

81. *Ibid.*, p. 21.

82. Lankheit (*The Blaue Reiter Almanac*) *op. cit.*, p. 155.

83. *Ibid.*, p. 152.

84. The presence of an illustration of Luke with the ox in *Der Blaue Reiter* (Lankheit [*The Blaue Reiter Almanac*], *op. cit.*, p. 200) suggests a similar appropriation by Marc of an animal symbol.

85. *Der Leinwandmesser*, 1913, K 632.

86. Leo Tolstoy, "Linen-Measurer," in *Pedagogical Articles, Linen-Measurer* (Boston, 1904), pp. 316-417.

87. Schardt, *op. cit.*, pp. 119-25.

88. Lankheit (*Sein Leben und Seine Kunst*), *op. cit.*, p. 120.

89. Wolf, *op. cit.*, p. 230.

90. K 755, K 883, K 831.

91. Lankheit (*The Blaue Reiter Almanac*), *op. cit.*, p. 76.

92. George Ferguson, *Signs and Symbols in Christian Art* (New York, 1954), p. 43.

93. K 874.

94. See also K 758.

95. Lankheit (*The Blaue Reiter Almanac*), *op. cit.*, p. 115.

96. Marc (*Briefe*), *op. cit.*, p. 122.

97. Angelica Zander Rudenstine, *The Guggenheim Museum Collection, Paintings 1880-1945*, Volume II (New York, 1976), p. 498.

98. Marc (*Briefe*), *op. cit.*, p. 28, letter to Macke, December 12, 1913.

99. Rudenstine, *op. cit.*, p. 498.

100. Lankheit (*Katalog*), *op. cit.*, p. 72.

101. Quoted in Frederick Spencer Levine, "The Iconography of Franz Marc's Fate of the Animals," *Art Bulletin*, 58 (June 1976), p. 269.

102. Quoted in Rudenstine, *op. cit.*, p. 499.

103. Quoted in Miesel, *op. cit.*, p. 7.

104. Quoted in Wolf, *op. cit.*, p. 226; quoted from Franz Marc, *Skizzenbuch aus dem Felde*. Introduction by Klaus Lankheit (Berlin, 1956), p. 6.

105. Quoted in Chipp, *op. cit.*, p. 182, letter of April 2, 1915.

106. Tolstoy, *op. cit.*, p. 370.

107. Rudenstine, *op. cit.*, p. 499.

108. Lankheit (*Sein Leben und Seine Kunst*), *op. cit.*, p. 122; also Frederick Spencer Levine quote from unpublished article "Franz Marc and the Birds."

109. Ferguson, *op. cit.*, p. 17.

110. Marc (*Briefe*), *op. cit.*, p. 127.

111. Levine ("Fate of the Animals"), *op. cit.*, p. 275; also Robert Rosenblum, *Modern Painting and the Northern Romantic Tradition* (New York, 1975), p. 145.

112. Leo Tolstoy, *What Is Art and Essays on Art*, translated by Louise and Aylmer Maude (London, 1899), p. 46.

113. Marc (*Briefe*), *op. cit.*, pp. 54-55, letter of March 29, 1915, and pp. 68-72, letter of April 18, 1915.

114. Tolstoy (*What Is Art and Essays on Art*), *op. cit.*, pp. 45-46.

115. Quoted in Lankheit (*Watercolors-Drawings-Writings*), *op. cit.*, p. 21.

116. Levine (*The Apocalyptic Vision*), *op. cit.*, pp. 222-23.

117. Klaus Lankheit, "Bibel-Illustration des Blauen Reiters," in *Anzeiger des Germanischen Nationalmuseums* (Ludwig Grote zum 70. Geburtstag), 1963, pp. 199-208.

118. Lankheit (*Sein Leben und Seine Kunst*), *op. cit.*, p. 130.

119. Rudenstine, *op. cit.*, p. 155.

120. *Abstract Forms*, 1914, K 622.

121. Marc (*Briefe*), *op. cit.*, pp. 81-82, 147.

122. Quoted in Hutton-Hutschnecker, *op. cit.*, p. x.

123. Lankheit (*Watercolors-Drawings-Writings*), *op. cit.*, p. 19.

124. Quoted in Hutton-Hutschnecker, *op. cit.*, p. x.

125. *Ibid.*, p. 52, letter to Kandinsky, October 24, 1914.

126. Paul Klee, *The Diaries of Paul Klee* (Berkeley and Los Angeles, 1968), pp. 319-320, no. 962.

127. *Ibid.*, p. 344, no. 1008.

128. Marc (*Briefe*), *op. cit.*, pp. 146-47.

129. Klee, *op. cit.*, p. 318, no. 961; see also p. 344, no. 1008.

130. *Ibid.*, pp. 323-24, no. 965.

131. Lankheit (*Watercolors-Drawings-Writings*), *op. cit.*, p. 20.

Plates

1. Portrait of the Artist's Mother, 1902
   Oil on canvas

2. Indersdorf, 1904
   Oil on canvas

4. Deer at the Edge of the Forest (Herd of Deer), 1907
   Watercolor, tempera and pastel on paper

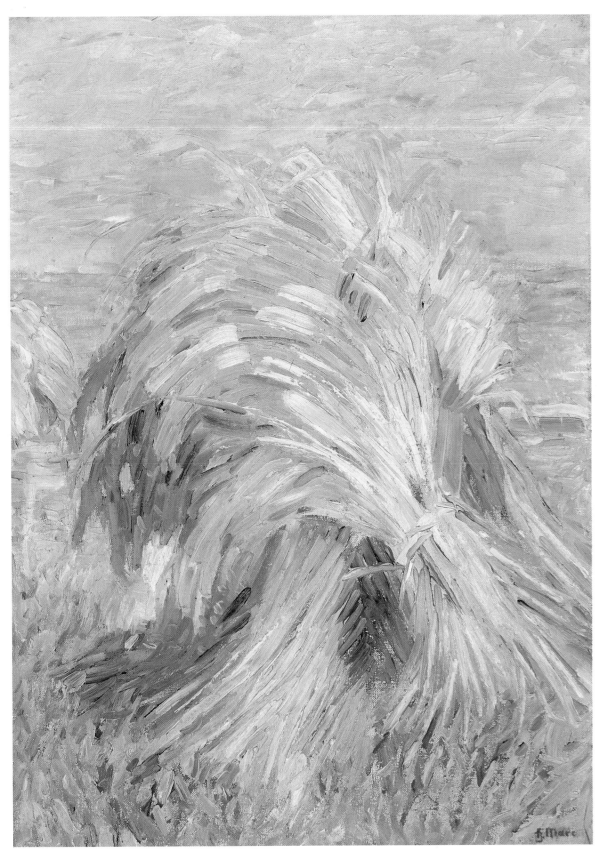

3. Sheaf of Grain, 1907
   Oil on canvas

5. Jumping Dog 'Schlick,' 1908
   Oil on cardboard

6. Large Lenggries Horse Painting I, 1908
   Oil on canvas

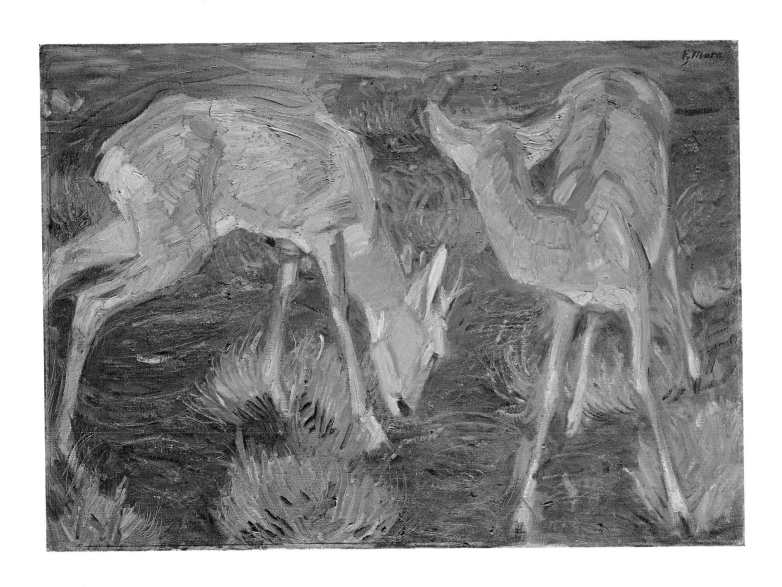

7. Deer at Dusk, 1909
   Oil on canvas

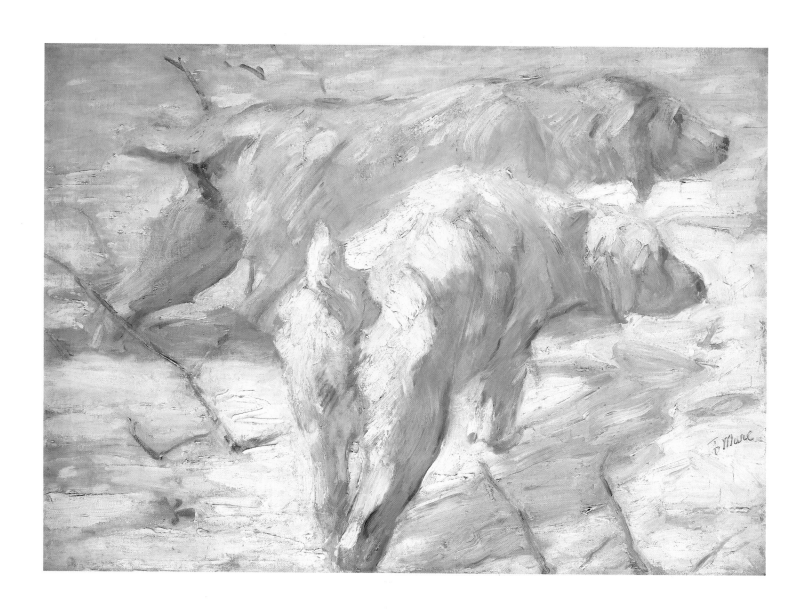

8. Siberian Sheepdogs (Siberian Dogs in the Snow), 1909-10
   Oil on canvas

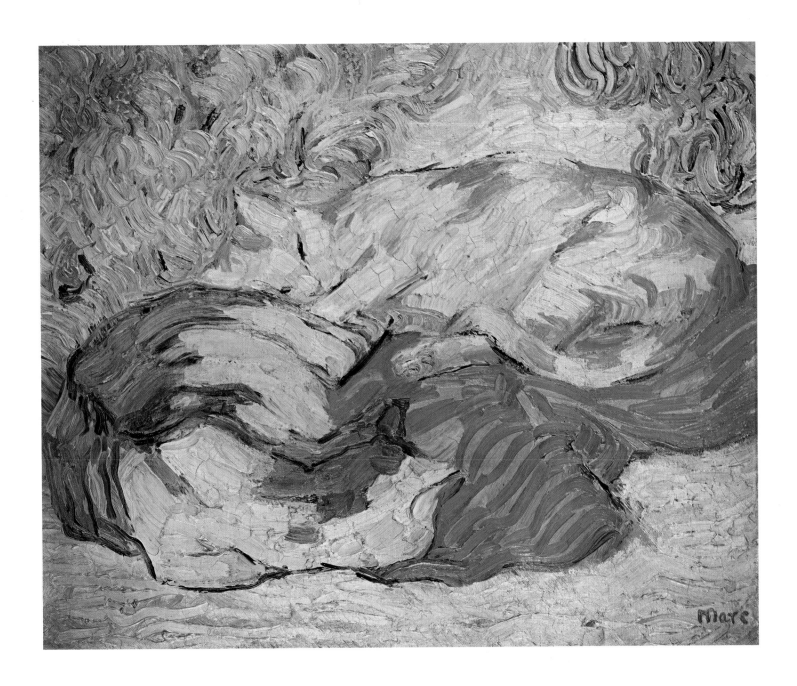

9. Cats, 1909-10
Oil on canvas

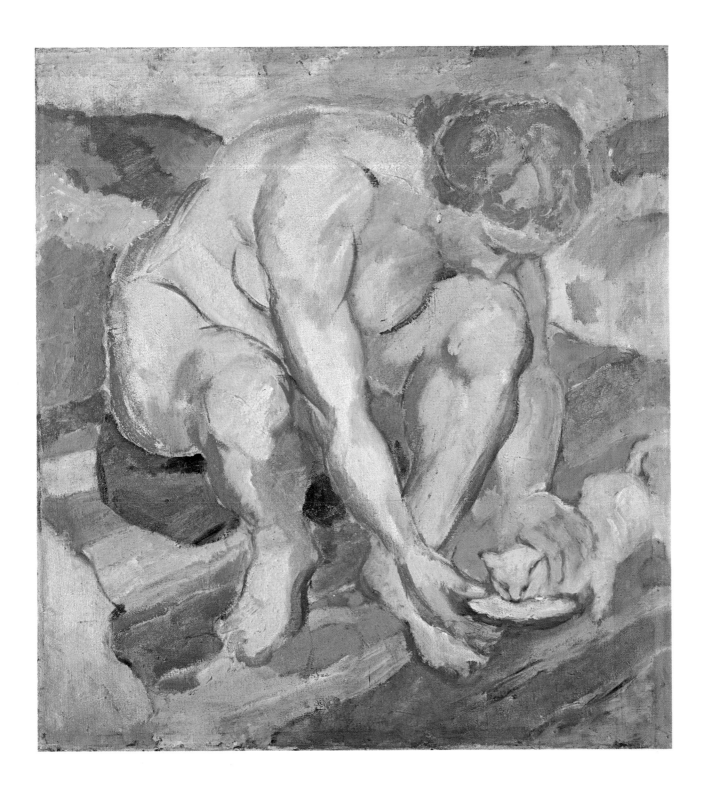

10. Nude with Cat, 1910
    Oil on canvas, doubled

11. Bathing Girls, 1910
   Oil on canvas

12. Grazing Horses I, 1910
    Oil on canvas, doubled

13. Horse in the Landscape, 1910
    Oil on canvas

14. Grazing Horses IV (The Red Horses), 1911
    Oil on canvas

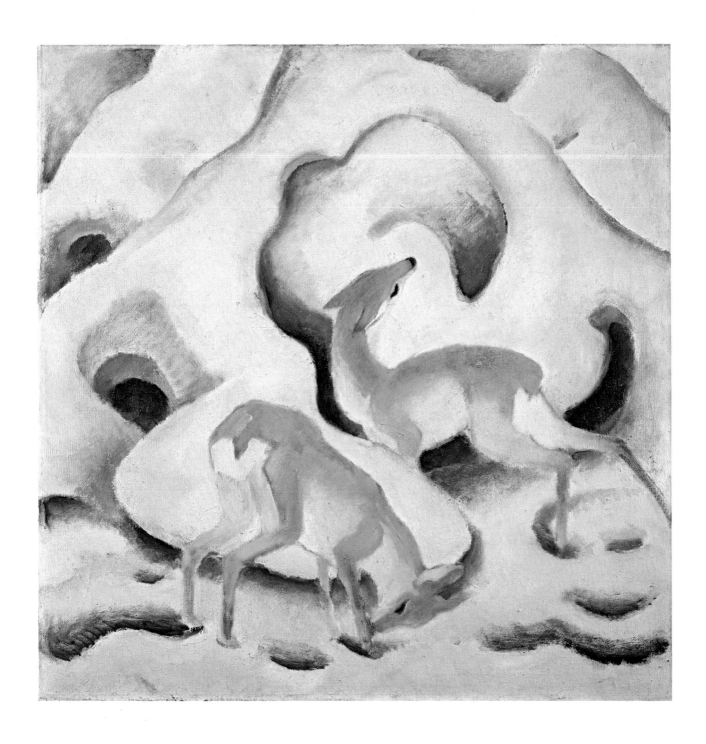

15. Deer in the Snow, 1911
    Oil on canvas

16. Weasels at Play, 1911
Oil on canvas

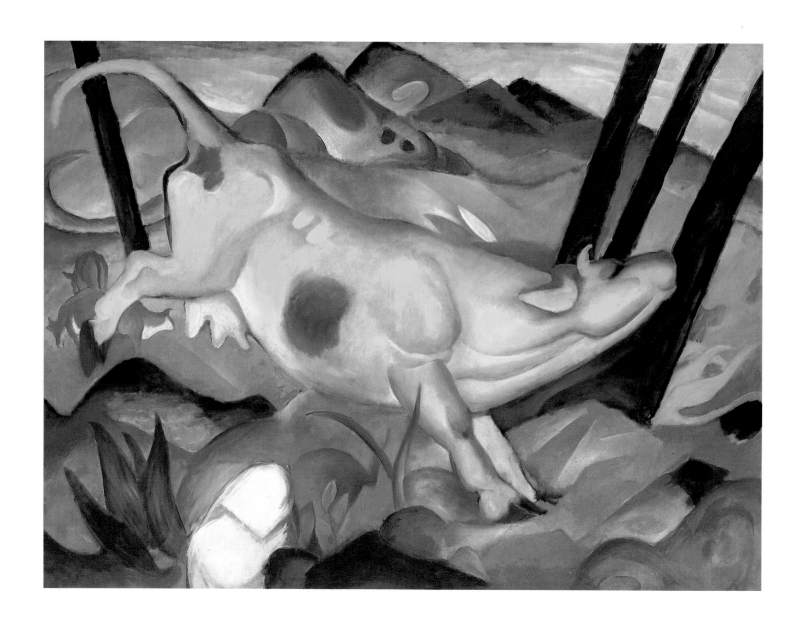

17. Yellow Cow, 1911
    Oil on canvas

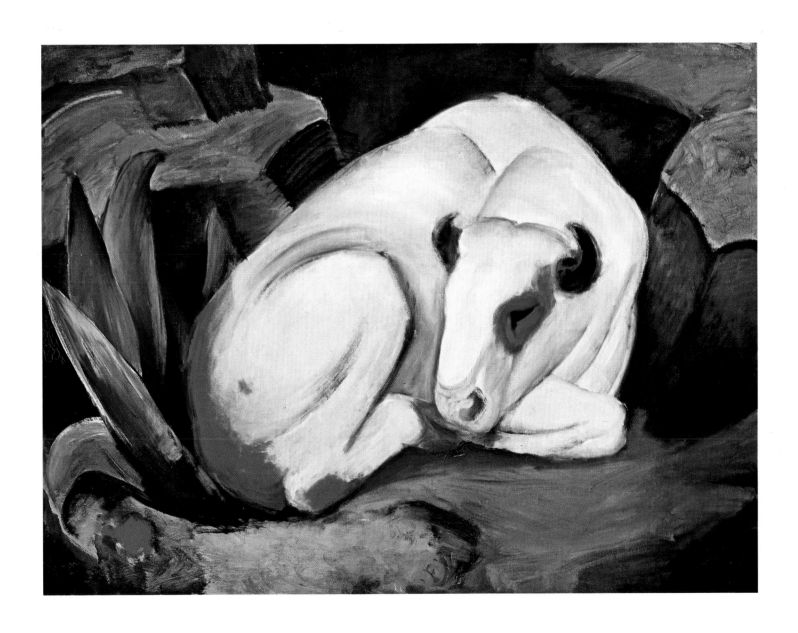

18. The Steer, 1911
   Oil on canvas

19. Blue Horse I, 1911
Oil on canvas

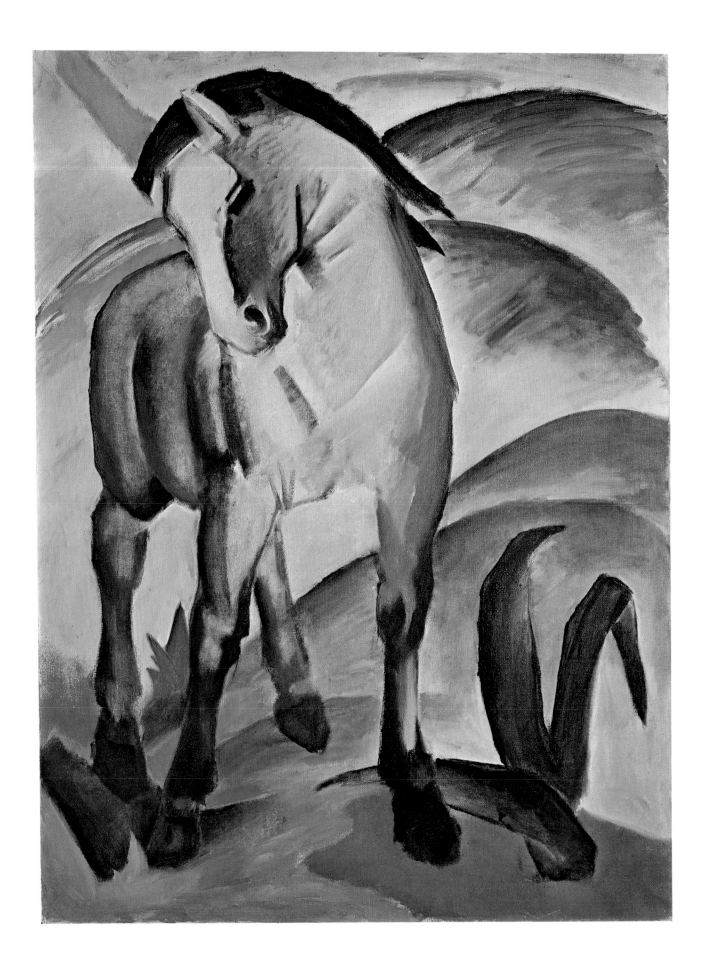

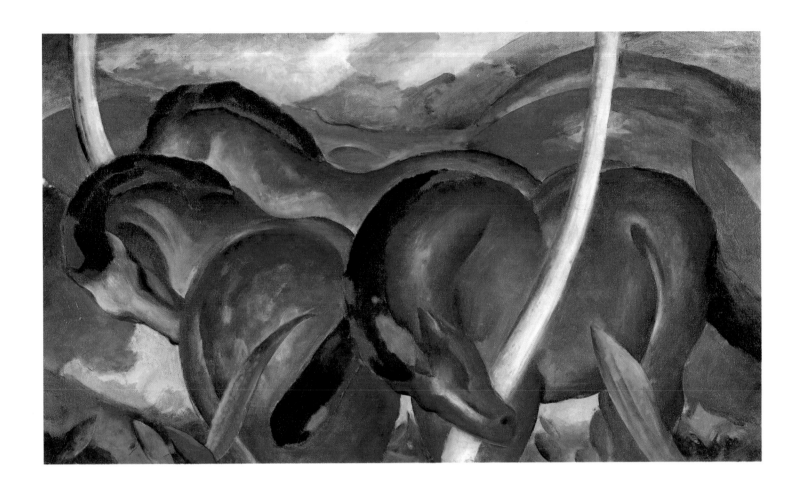

20. The Large Blue Horses, 1911
    Oil on canvas

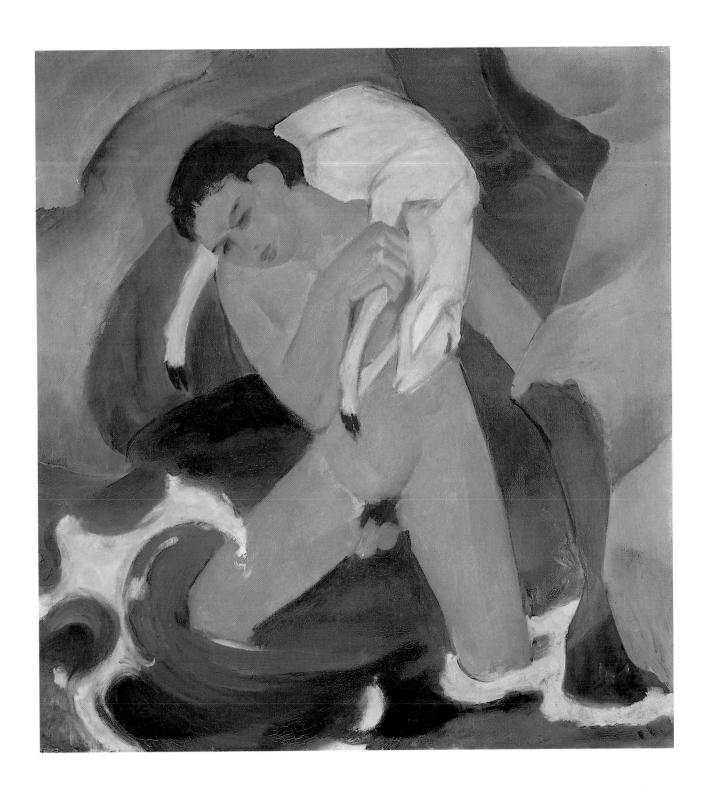

21. Young Boy with a Lamb, 1911
    Oil on canvas

22. Woodcutter, 1911
   Oil on canvas

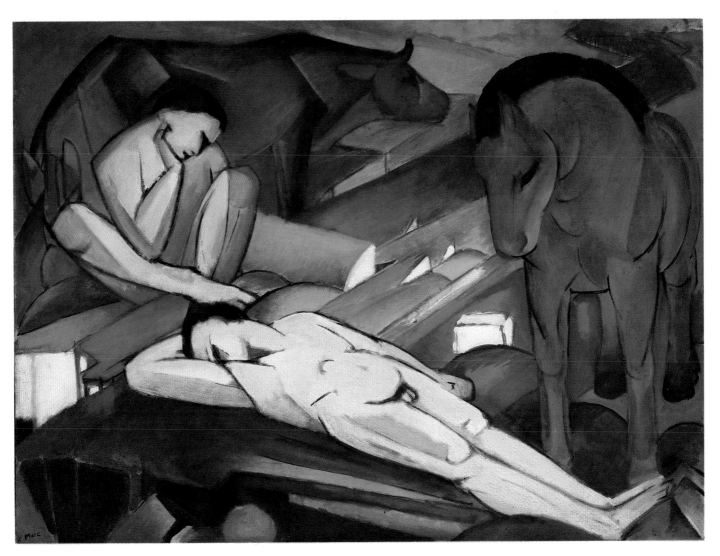

23. Shepherds, c. 1911-12
   Oil on canvas

Kat. 19 12/3                    2 Pferd (bemalte Buchdruck)

24. Two Horses, 1911-12
    Tempera over Letterpress

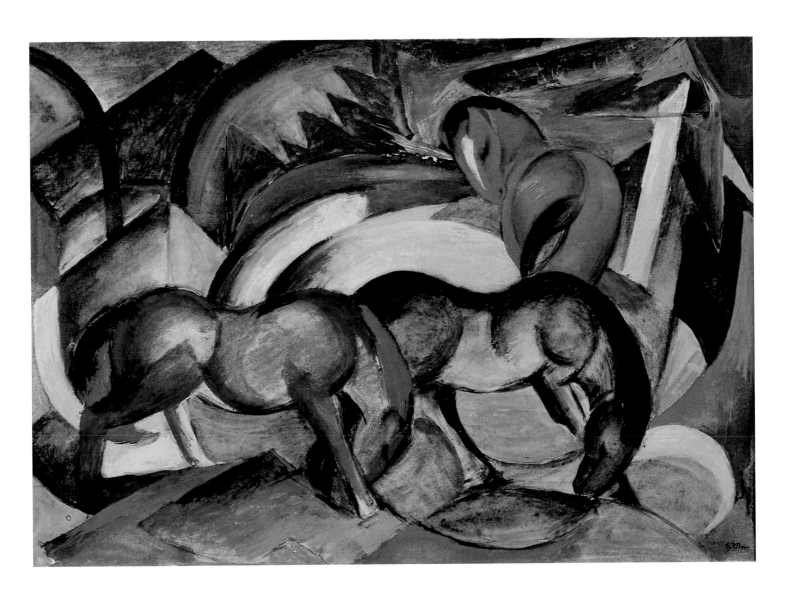

25. Three Horses, 1912
Mixed media on paper

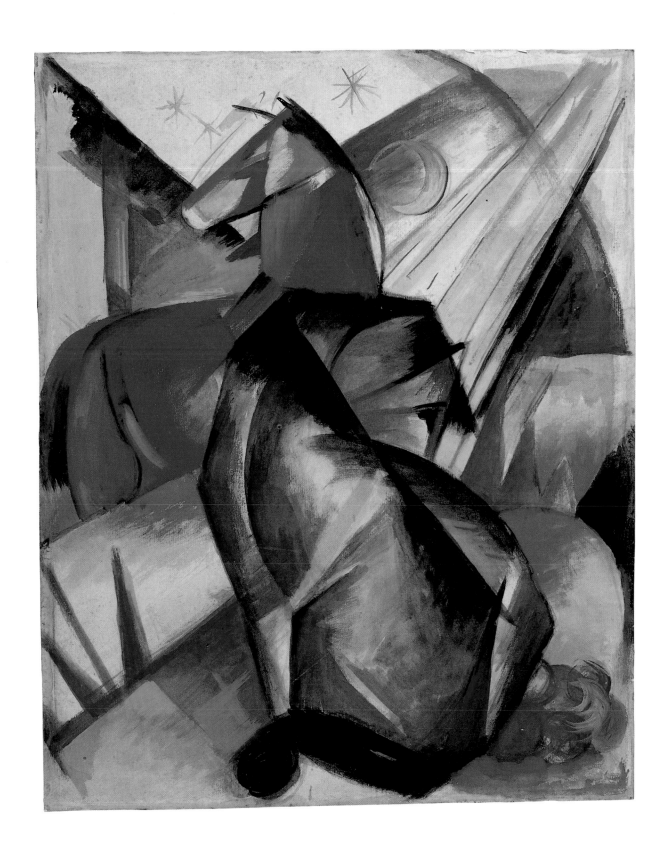

26. Two Horses, Red and Blue, 1912
   Watercolor on paper

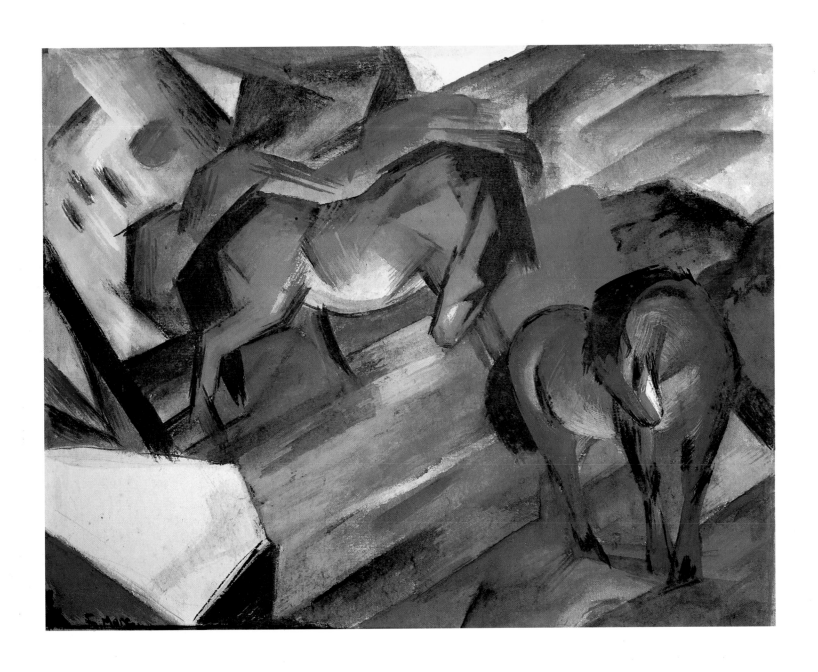

27. Red and Blue Horse, 1912
    Tempera on paper

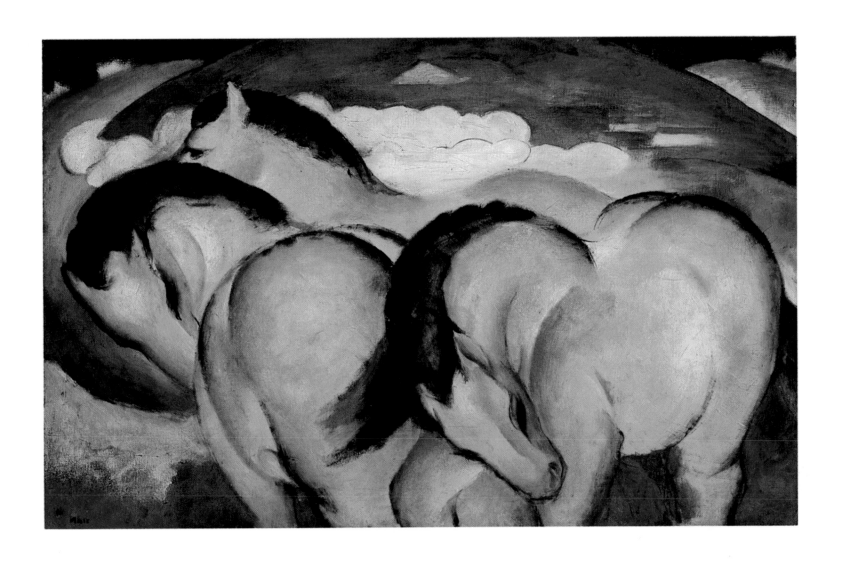

28. The Little Yellow Horses, 1912
    Oil on canvas

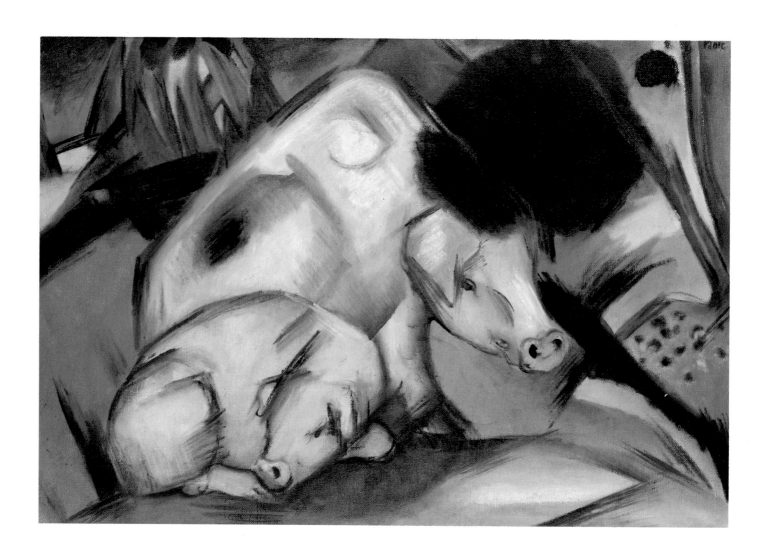

29. Pigs, 1912
   Oil on canvas

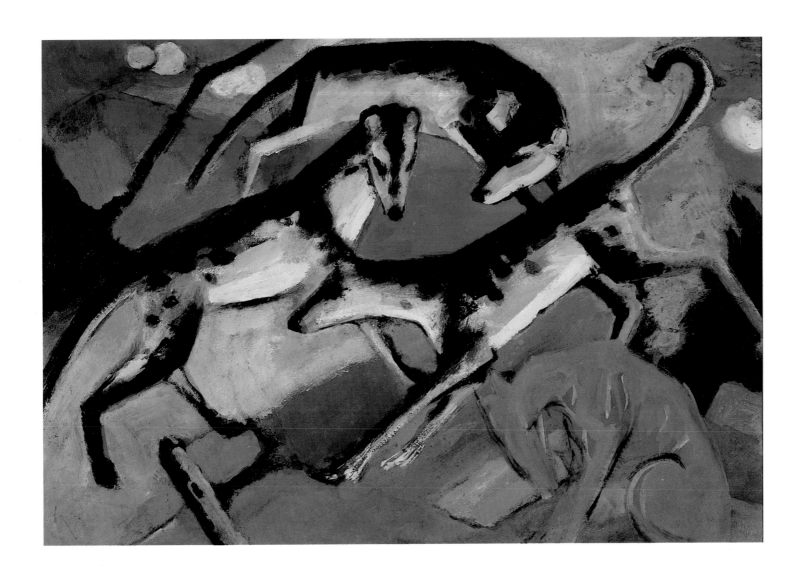

30. Playing Dogs, c. 1912
    Tempera on board

31. Deer in the Forest, 1912
Oil on canvas

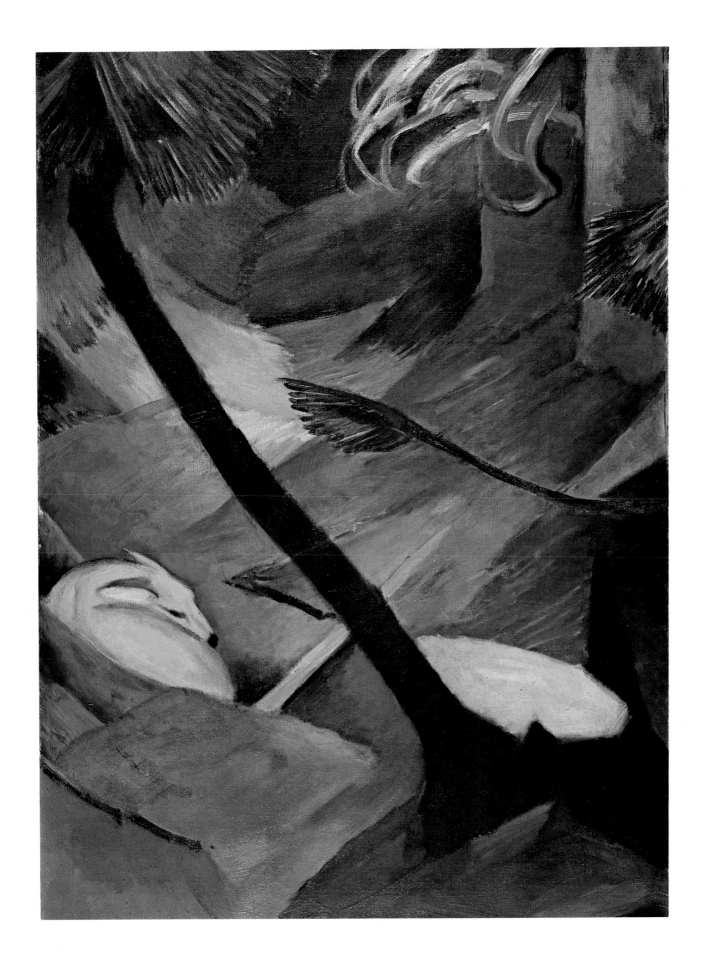

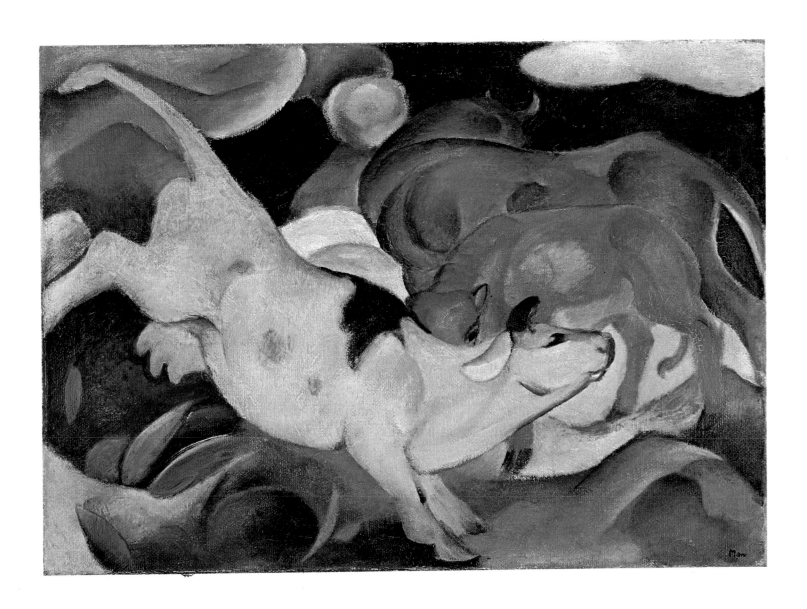

32. Cows, Yellow, Red, Green, 1912
Oil on canvas

33. The Monkey, 1912
   Oil on canvas

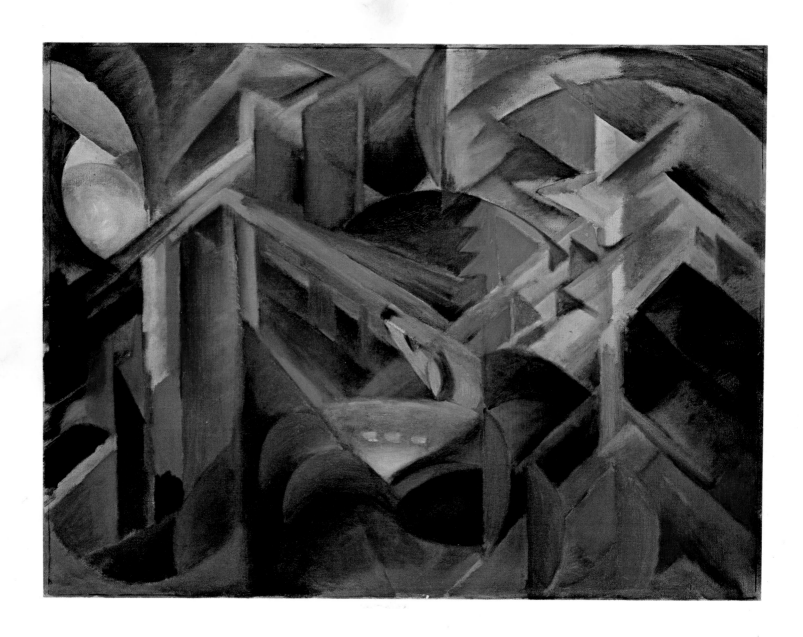

34. Deer in a Monastery Garden, 1912
   Oil on canvas

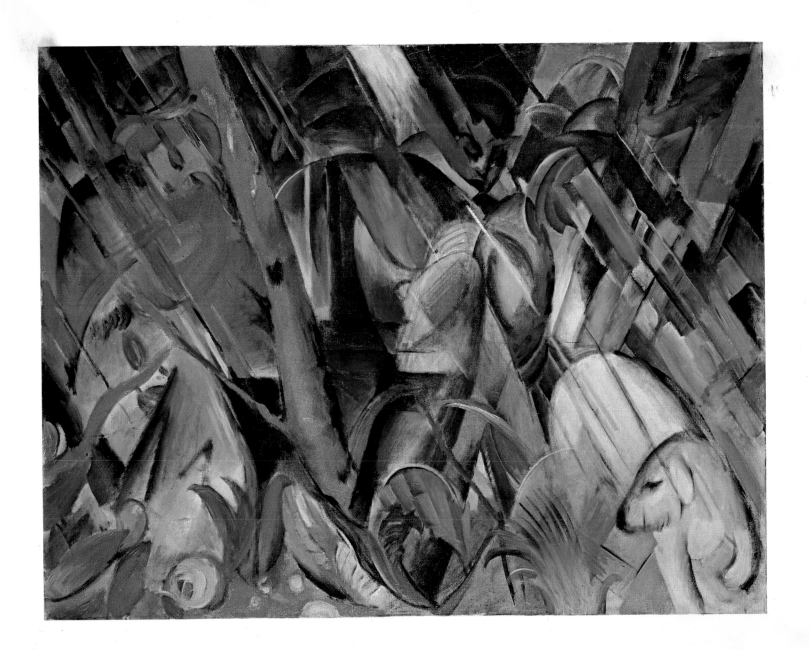

35. Rain, 1912
   Oil on canvas

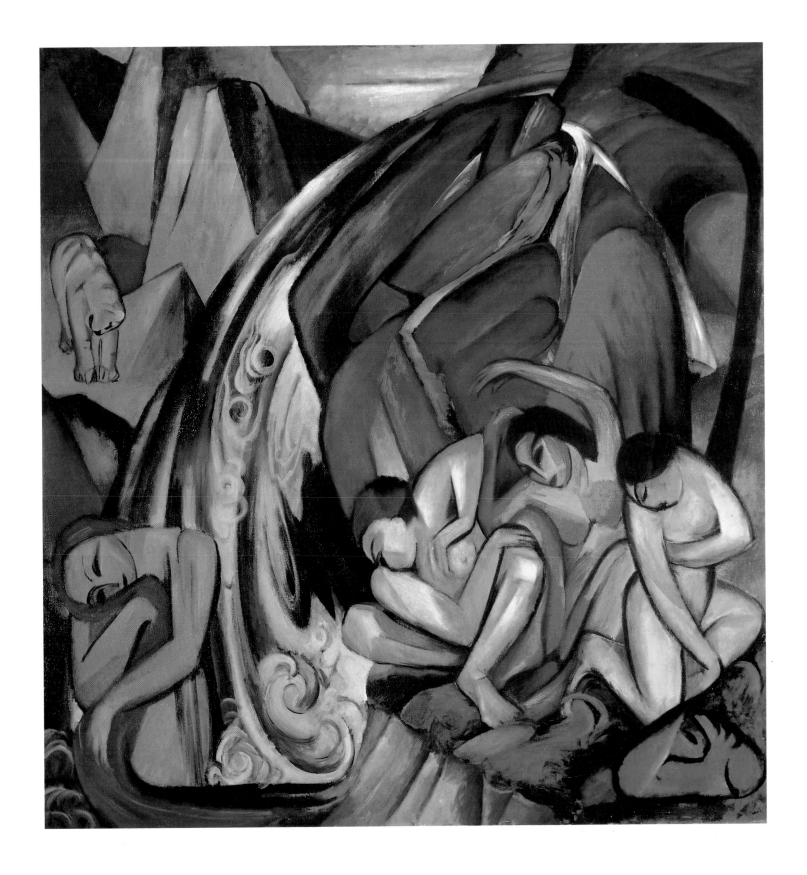

36. The Waterfall, 1912
   Oil on canvas

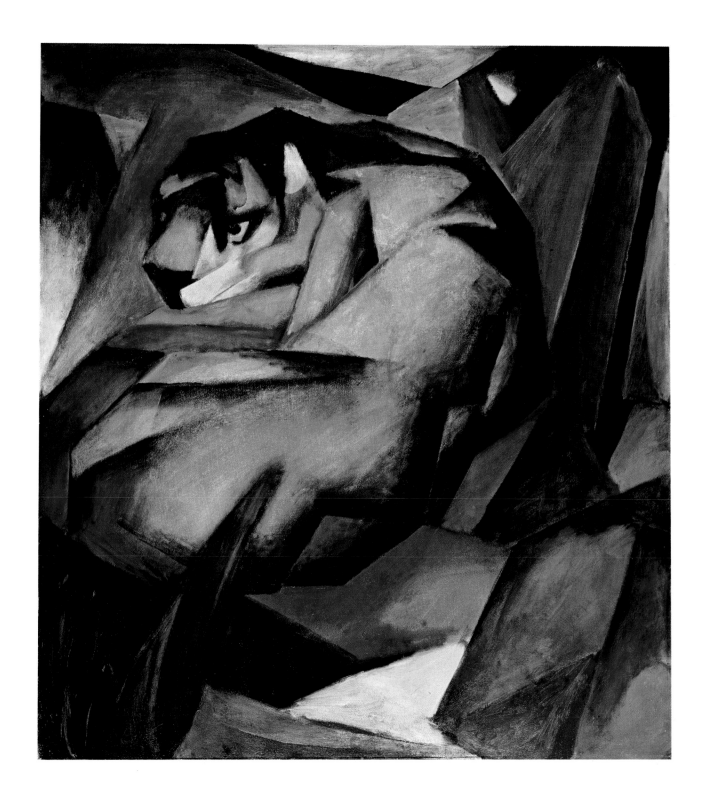

37. The Tiger, 1912
   Oil on canvas

38. Mountains (Rocky Way/Landscape), 1911-12
Oil on canvas

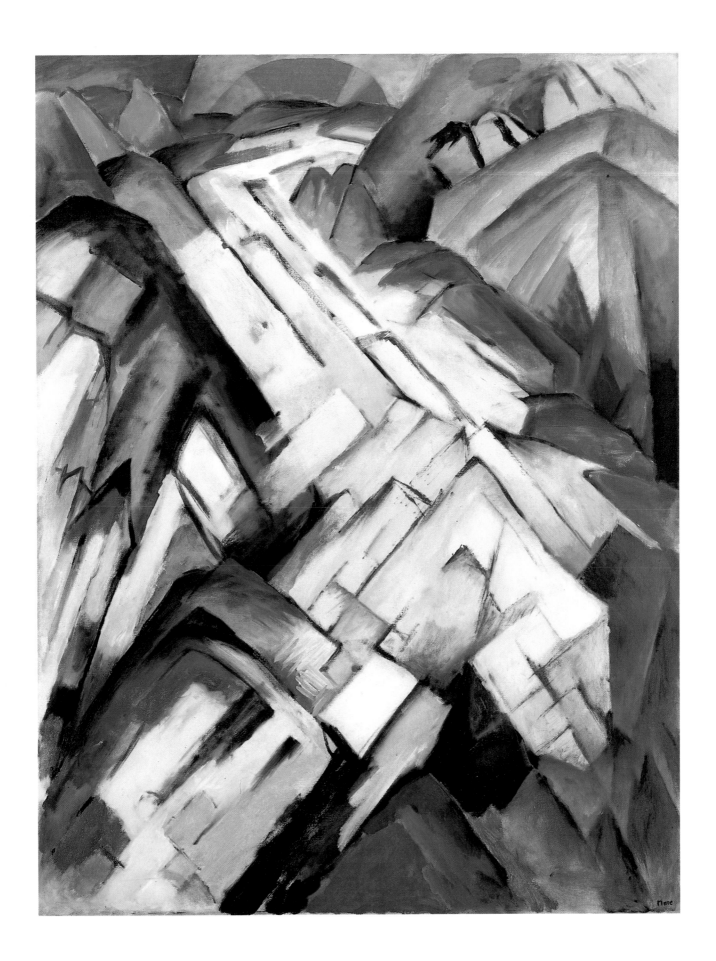

39. The Bewitched Mill, 1913
Oil on canvas

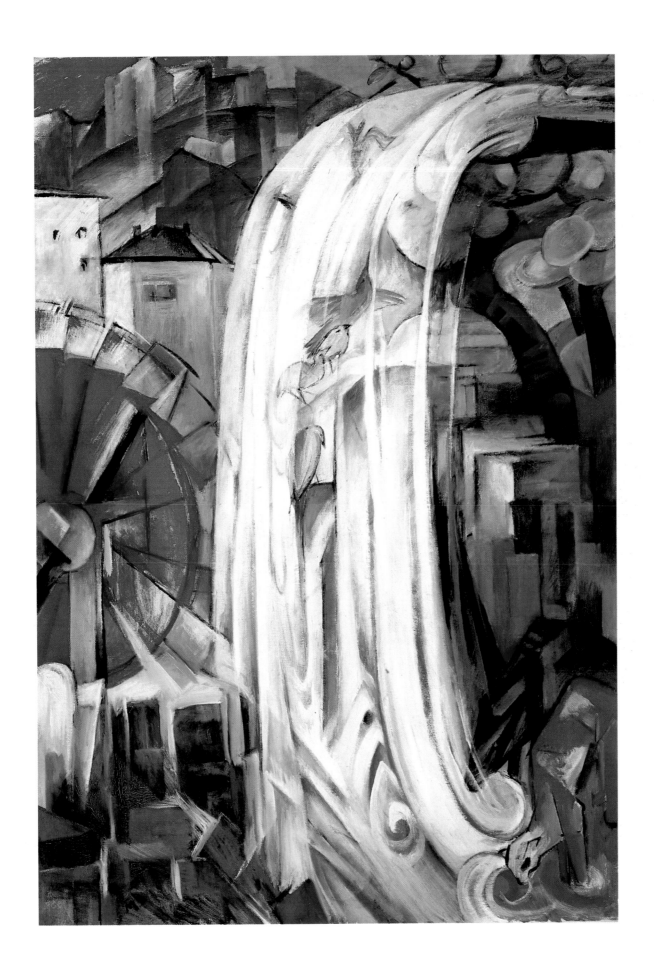

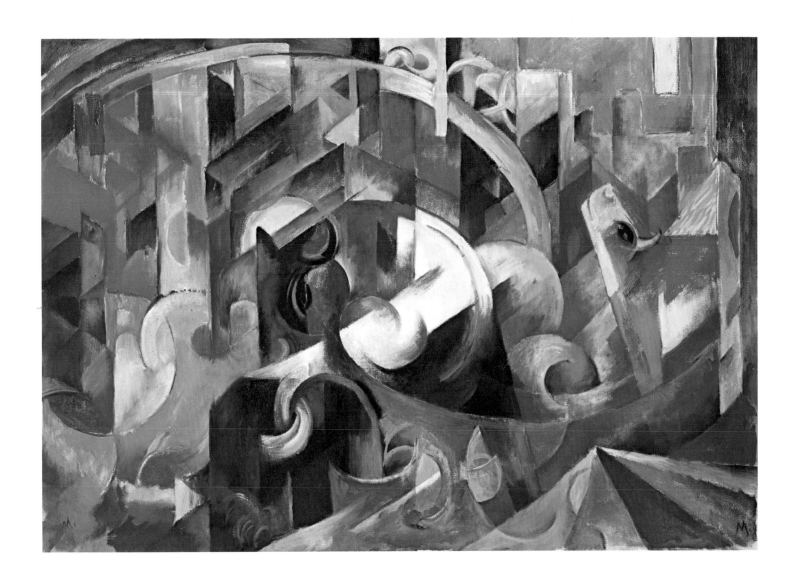

40. Painting with Cattle, 1913
   Oil on canvas

41. Birth of the Horses, 1913
Color woodcut

42. Horse Asleep, 1913 (?)
   Watercolor, ink on laid paper

43. Two Blue Horses, 1913
   Gouache and ink on paper

44. Colorful Flowers (Abstract Forms), 1913-14
Tempera on paper

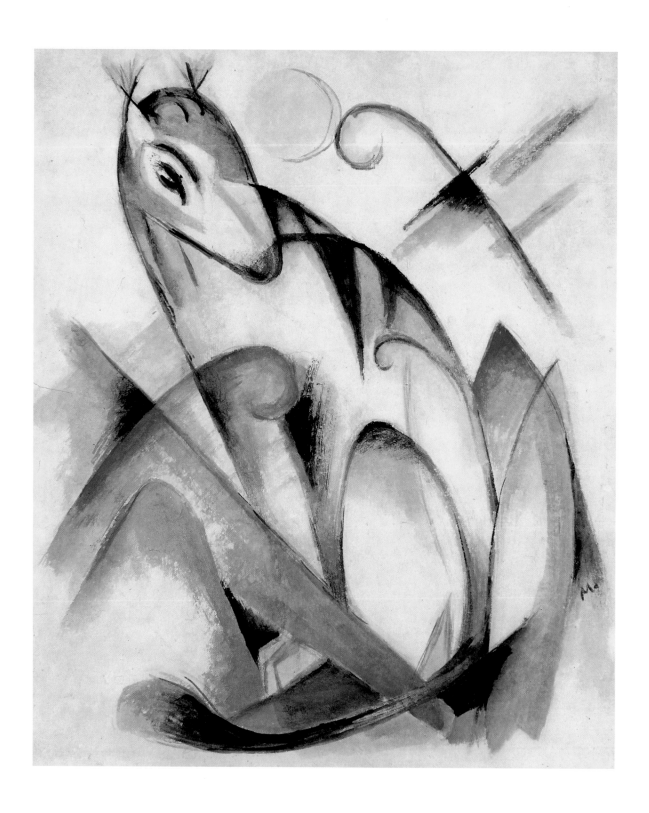

45. Seated Mythical Animal, 1913
Tempera on paper

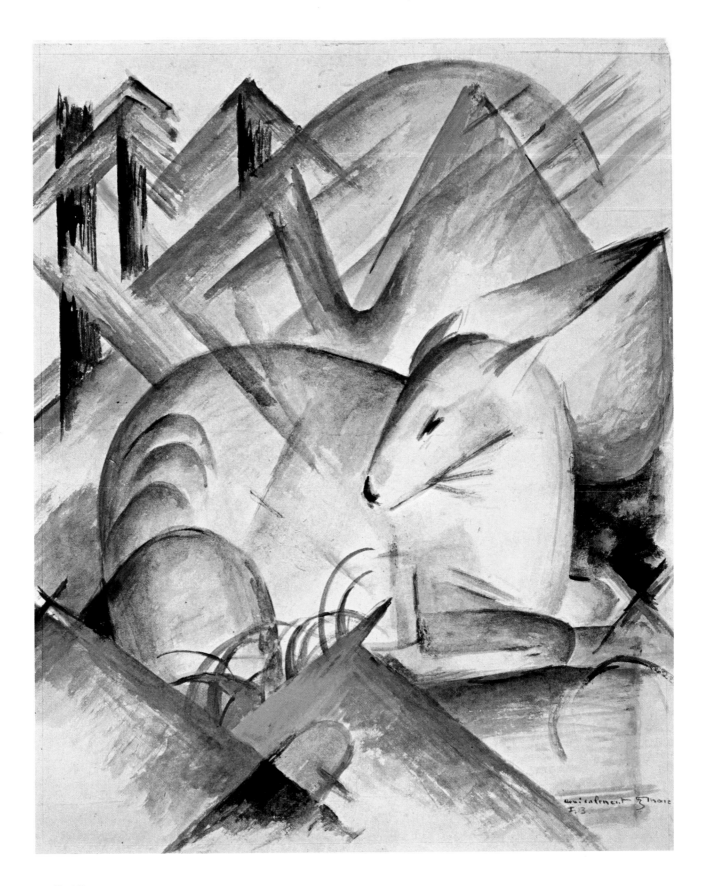

46. Red Deer, 1913
   Tempera

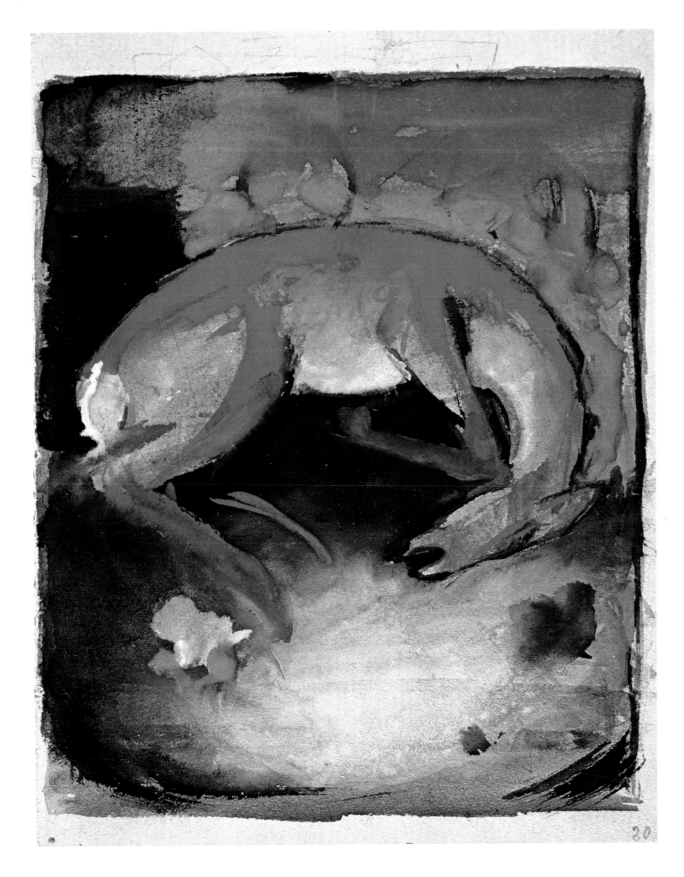

47. Dead Deer, 1913
Watercolor

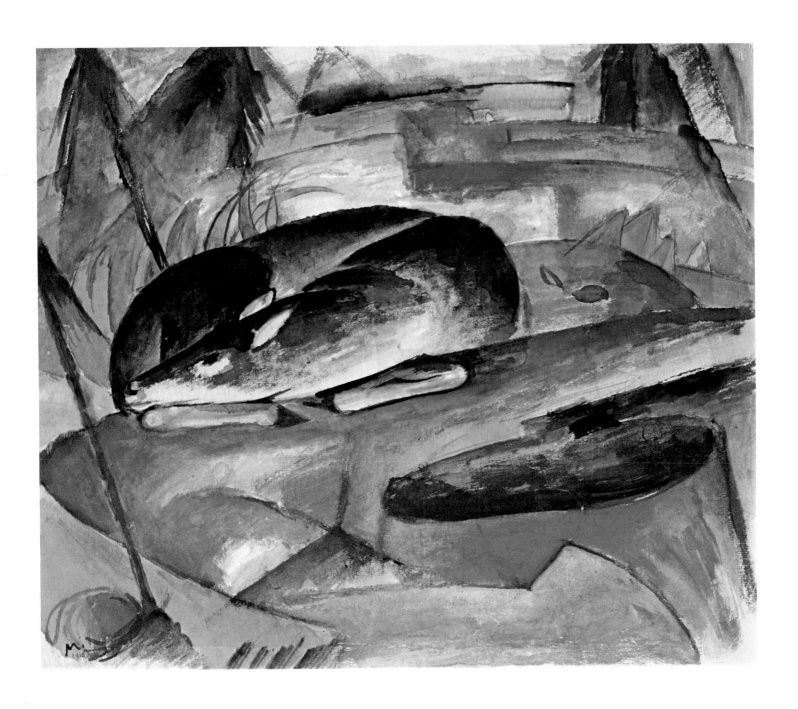

48. Sleeping Deer, 1913
Tempera

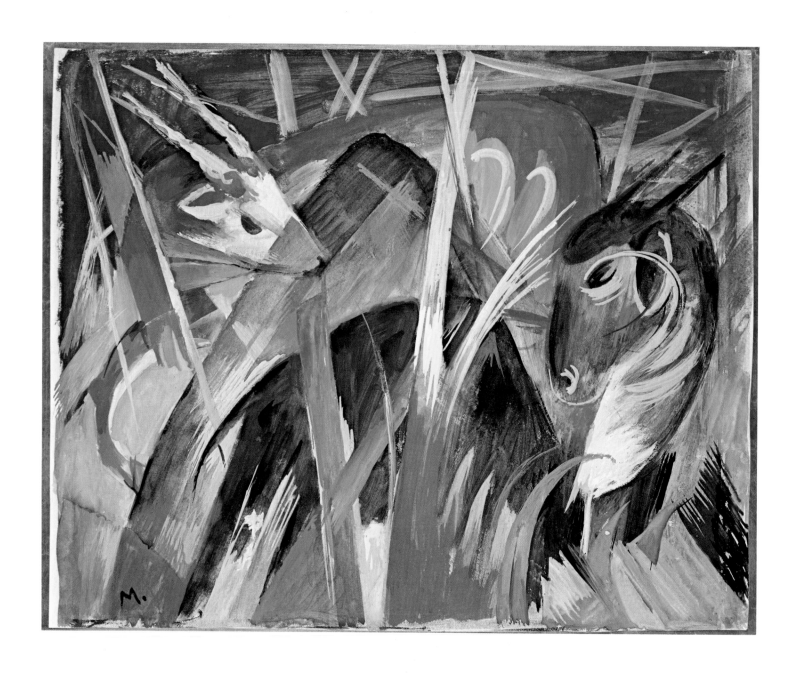

49. Fairy Animals I, 1913
   Tempera

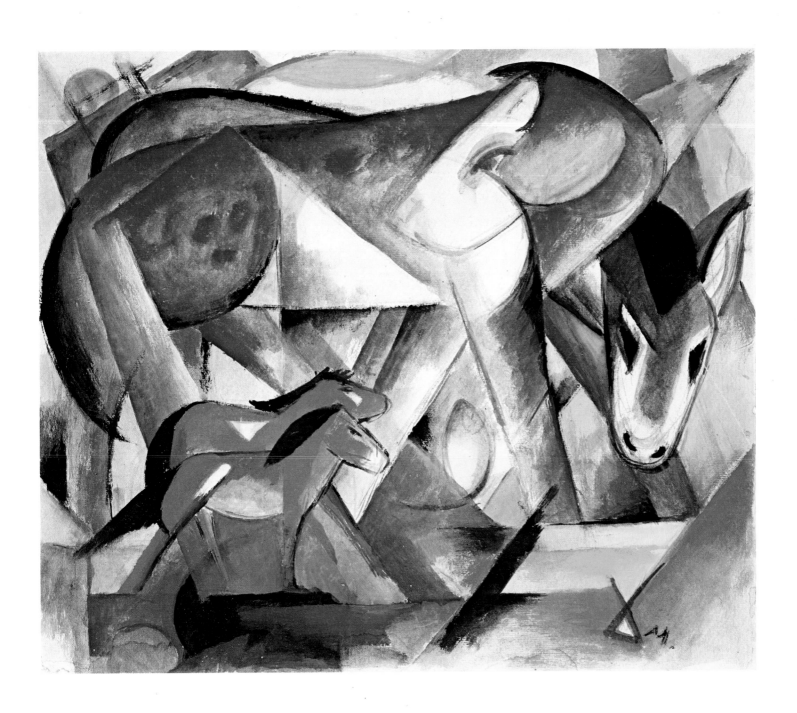

50. The First Animals, 1913
   Tempera

51. Sleeping Animals, 1913
Tempera

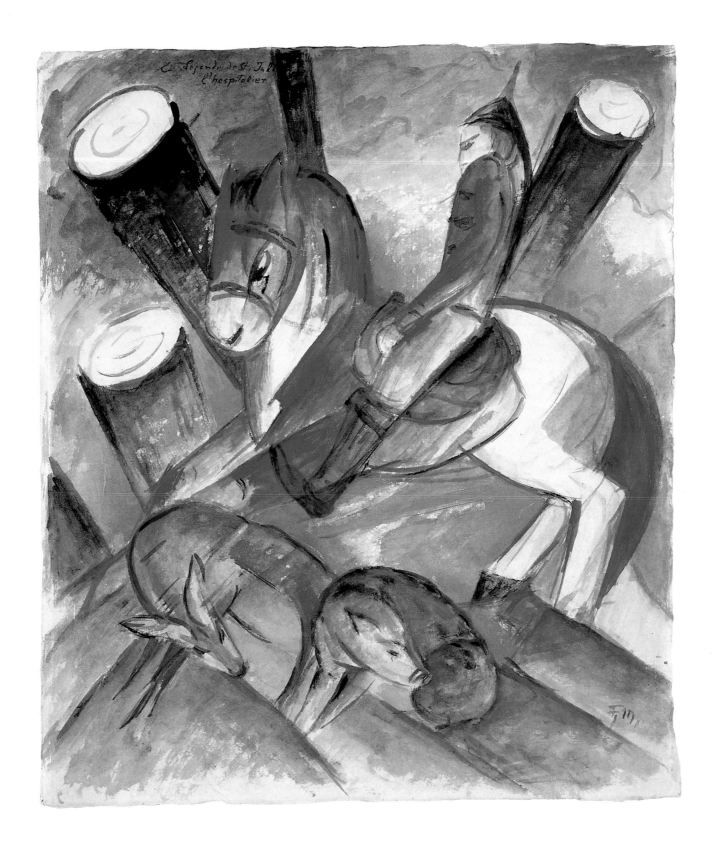

52. Saint Julian l'Hospitalier, 1913
    Gouache with ink and gold on paper

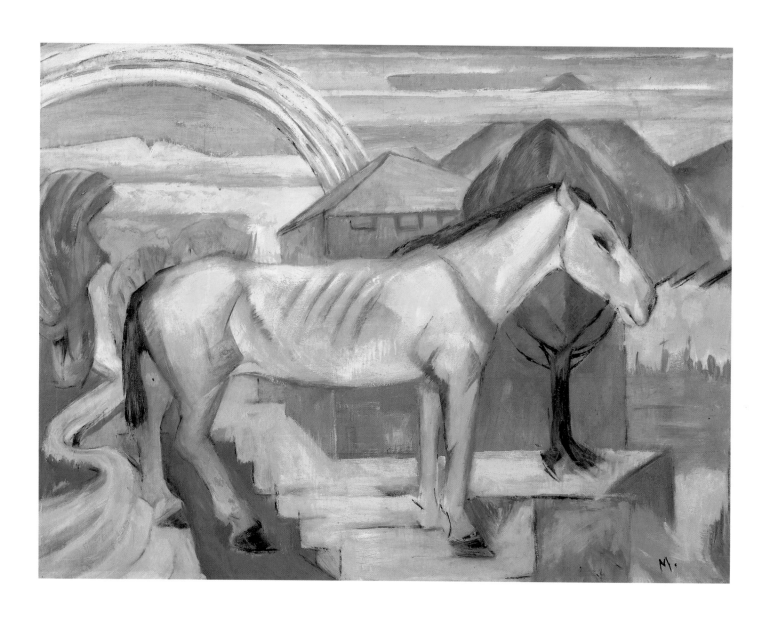

53. Long Yellow Horse, 1913
Oil on canvas

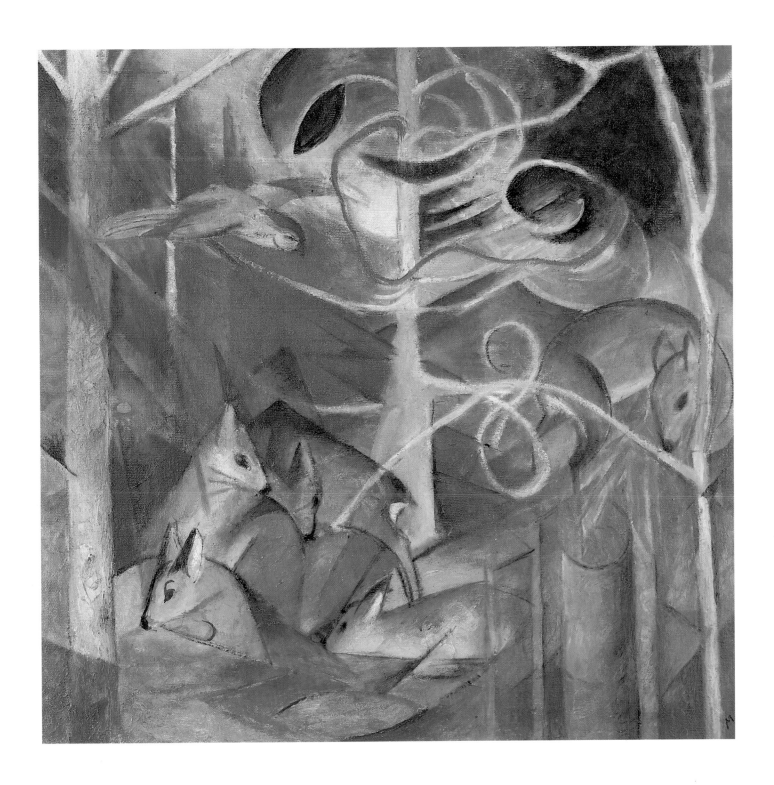

54. Deer in the Forest I, 1913
   Oil on canvas

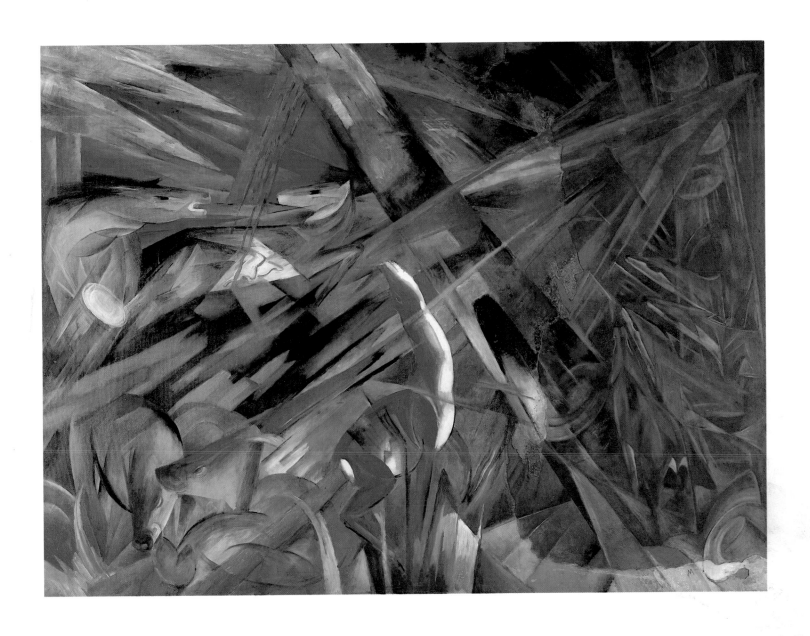

55. Fate of the Animals, 1913
   Oil on canvas

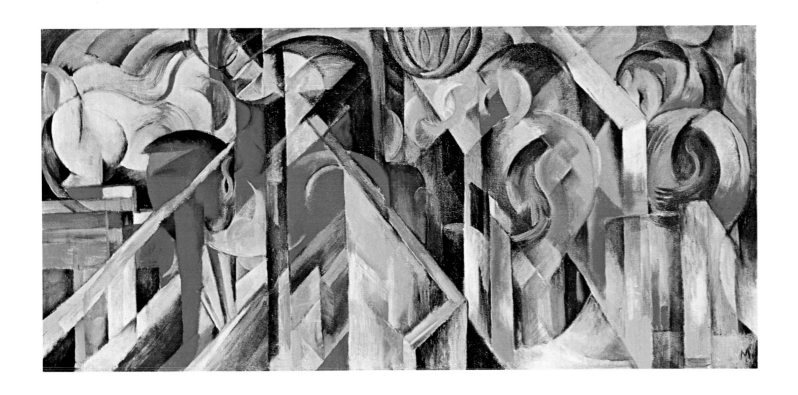

56. Stables, 1913
    Oil on canvas

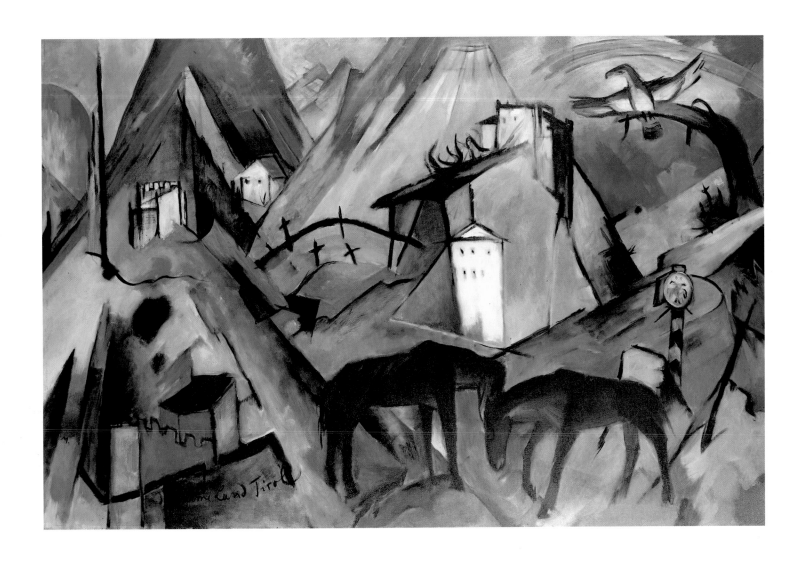

57. The Unfortunate Land of Tirol, 1913
    Oil on canvas

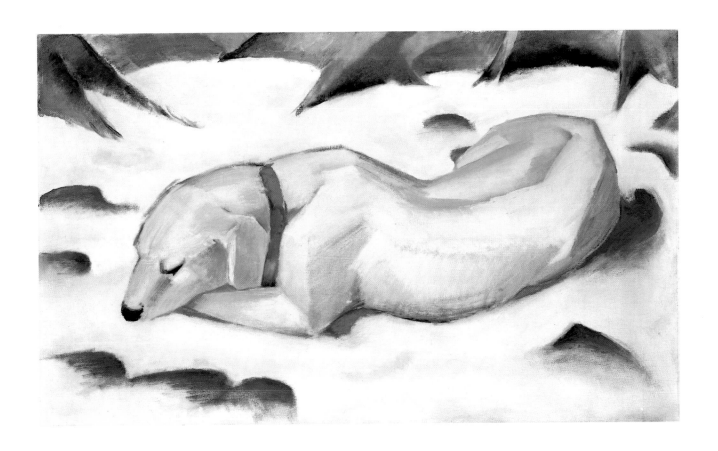

58. The White Dog, c. 1913-14
Oil on canvas

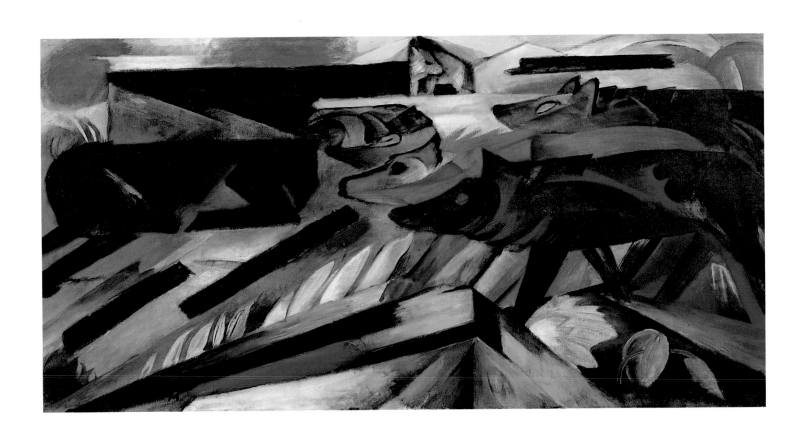

59. The Wolves (Balkan War), 1913
Oil on canvas

60. Mountain Goats, 1914
    Watercolor

61. Small Composition II, 1914
Oil on canvas

62. Small Composition III, 1914
Oil on canvas

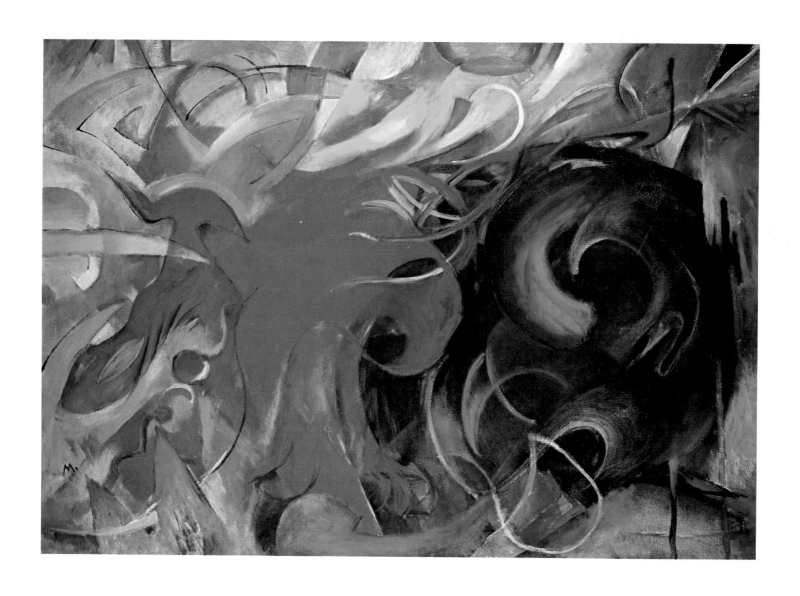

63. Fighting Forms, 1914
   Oil on canvas

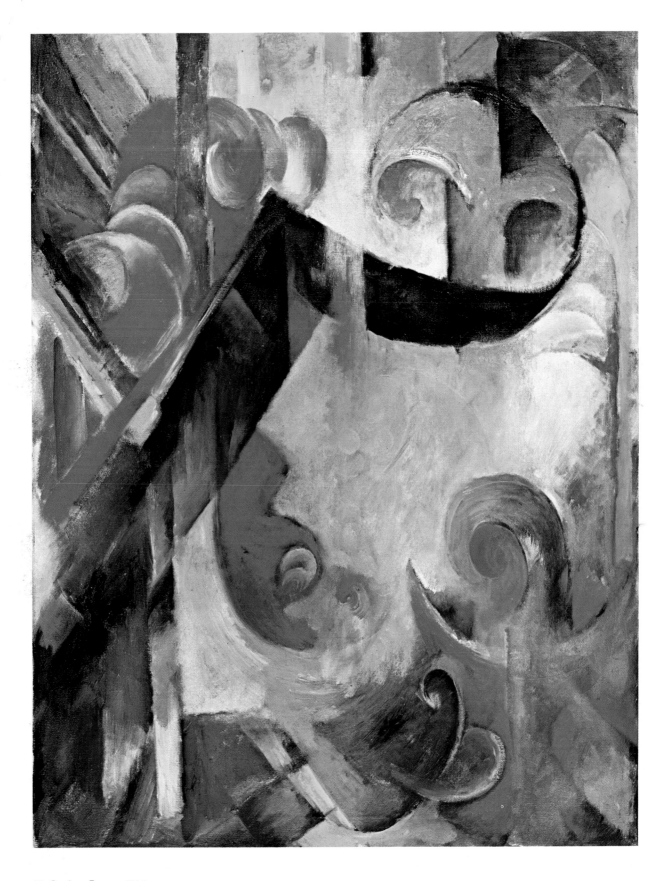

64. Broken Forms, 1914
    Oil on canvas

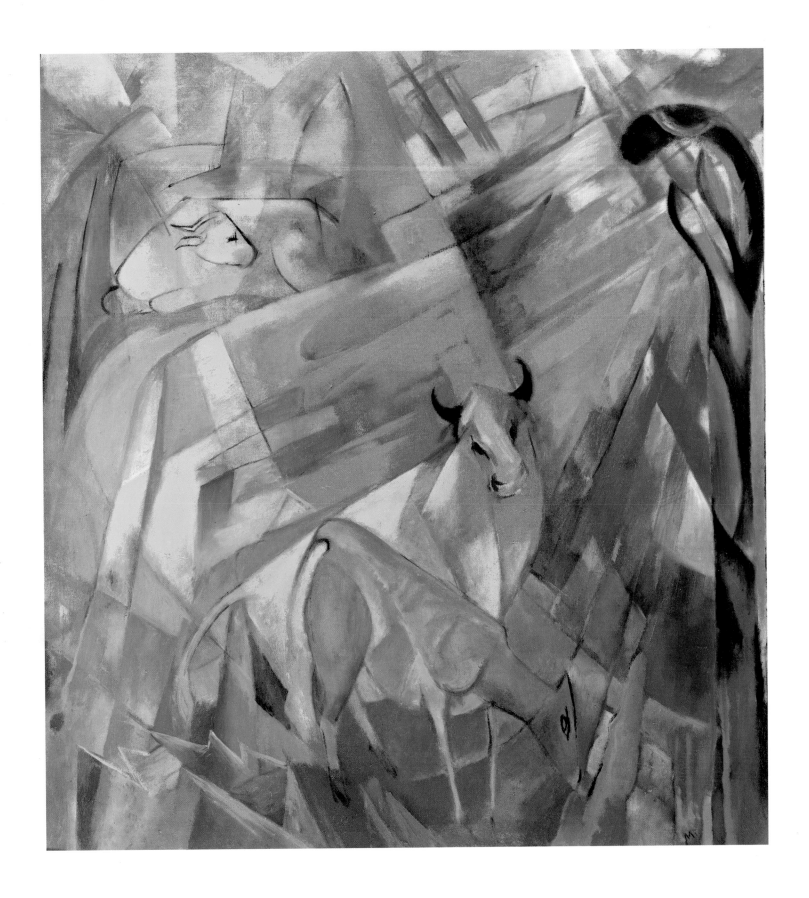

65. Animals in Landscape (Painting with Bulls II), 1914
Oil on canvas

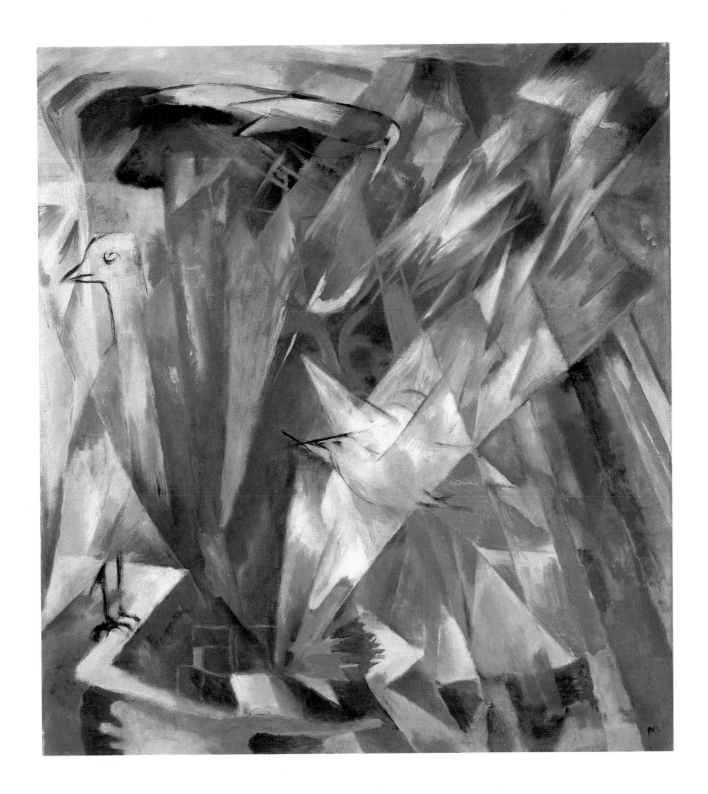

66. The Birds, 1914
   Oil on canvas

# Appendix

## List of Text Illustrations

153

# List of Plates

1. *Portrait of the Artist's Mother*, 1902
   Oil on canvas
   38³/₄x27¹/₂ in. (98.5x70 cm)
   Städtische Galerie im Lenbachhaus, Munich

2. *Indersdorf*, 1904
   Oil on canvas
   15³/₄x12³/₈ in. (40x31.5 cm)
   Städtische Galerie im Lenbachhaus, Munich, on
   permanent loan from the Gabriele Münter und
   Johannes Eichner-Stiftung

3. *Sheaf of Grain*, 1907
   Oil on canvas
   31x23 in. (78.8x58.4 cm)
   The University of Iowa Museum of Art, Iowa
   City, Iowa, gift of Owen and Leone Elliott

4. *Deer at the Edge of the Forest (Herd of Deer)*,
   1907
   Watercolor, tempera and pastel on paper
   5¹/₂x13 in. (14x33 cm)
   The Baltimore Museum of Art, Baltimore,
   Maryland, bequest of Saidie A. May

5. *Jumping Dog 'Schlick,'* 1908
   Oil on cardboard
   21¹/₂x26¹/₂ in. (54.5x67.5 cm)
   Städtische Galerie im Lenbachhaus, Munich

6. *Large Lenggries Horse Painting I*, 1908
   Oil on canvas
   41¹/₄x81¹/₈ in. (104.8x206 cm)
   Private Collection

7. *Deer at Dusk*, 1909
   Oil on canvas
   27³/₄x40 in. (70.5x100.5 cm)
   Städtische Galerie im Lenbachhaus, Munich,
   gift of Gabriele Münter

8. *Siberian Sheepdogs (Siberian Dogs in the Snow)*,
   1909-10
   Oil on canvas
   31⁵/₈x44⁷/₈ in. (80.5x114 cm)
   National Gallery of Art, Washington, gift of Mr.
   and Mrs. Stephen M. Kellen

9. *Cats*, 1909-10
   Oil on canvas
   19⁷/₈x23⁷/₈ in. (50.5x60.5 cm)
   Private Collection

10. *Nude with Cat*, 1910
    Oil on canvas, doubled
    34⁵/₈x32¹/₄ in. (88x82 cm)
    Städtische Galerie im Lenbachhaus, Munich

11. *Bathing Girls*, 1910
    Oil on canvas
    43x55³/₄ in. (106.7x141.6 cm)
    Norton Simon Art Foundation

12. *Grazing Horses I*, 1910
    Oil on canvas, doubled
    25¹/₄x37 in. (64x94 cm)
    Städtische Galerie im Lenbachhaus, Munich,
    gift of the Government of Bavaria

13. *Horse in the Landscape*, 1910
    Oil on canvas
    33¹/₂x44 in. (85x112 cm)
    Museum Folkwang, Essen

14. *Grazing Horses IV (The Red Horses)*, 1911
    Oil on canvas
    47⁵/₈x72 in. (121x182.9 cm)
    Private Collection

15. *Deer in the Snow*, 1911
    Oil on canvas
    33³/₈x33¹/₄ in. (84.7x84.5 cm)
    Städtische Galerie im Lenbachhaus, Munich,
    gift of Elly Koehler

16. *Weasels at Play*, 1911
    Oil on canvas
    40¹/₈x26³/₈ in. (101.9x67 cm)
    Private Collection

17. *Yellow Cow*, 1911
    Oil on canvas
    55³/₈x74¹/₂ in. (140.6x189.2 cm)
    Solomon R. Guggenheim Museum, New York

18. *The Steer*, 1911
    Oil on canvas
    39³/₄x53¹/₈ in. (101x135 cm)
    Solomon R. Guggenheim Museum, New York

19. *Blue Horse I*, 1911
    Oil on canvas
    44x33¹/₄ in. (112x84.5 cm)
    Städtische Galerie im Lenbachhaus, Munich,
    Bernhard Koehler-Stiftung

20. *The Large Blue Horses*, 1911
    Oil on canvas
    41¹/₄x71¹/₂ in. (104.8x181 cm)
    Walker Art Center, Minneapolis, Minnesota,
    gift of the T. B. Walker Foundation, Gilbert
    M. Walker Fund, 1942

21. *Young Boy with a Lamb*, 1911
    Oil on canvas
    34⁵/₈x33 in. (88x83.8 cm)
    Solomon R. Guggenheim Museum, New York

22. *Woodcutter*, 1911
    Oil on canvas
    55¹/₂x42⁷/₈ in. (141x109 cm)
    Collection Gregory Callimanopulos

23. *Shepherds*, c. 1911-12
    Oil on canvas
    39³/₈x53¹/₈ in. (100x135 cm)
    Bayerische Staatsgemäldesammlungen, Staats-
    galerie moderner Kunst, Munich, loan

24. *Two Horses*, 1911-12
    Tempera over letterpress
    5¹/₂x8¹/₄ in. (14x21 cm)
    Städtische Galerie im Lenbachhaus, Munich,
    Estate

25. *Three Horses*, 1912
    Mixed media on paper
    14⁵/₈x20³/₈ in. (37.1x51.7 cm)
    Private Collection

26. *Two Horses, Red and Blue*, 1912
    Watercolor on paper
    17¹/₂x15 in. (44.5x38.1 cm)
    Museum of Art, Rhode Island School of
    Design, Providence, Rhode Island

27. *Red and Blue Horse*, 1912
    Tempera on paper
    10³/₈x13¹/₂ in. (26.3x43.3 cm)
    Städtische Galerie im Lenbachhaus, Munich

28. *The Little Yellow Horses*, 1912
    Oil on canvas
    26x40⁷/₈ in. (66x104 cm)
    Staatsgalerie Stuttgart

29. *Pigs*, 1912
    Oil on canvas
    22⁷/₈x33 in. (58.1x83.8 cm)
    Private Collection, Switzerland

30. *Playing Dogs*, c. 1912
    Tempera on board
    15x21¹/₂ in. (38.1x54.6 cm)
    Busch-Reisinger Museum, Harvard University,
    Cambridge, Massachusetts

31. *Deer in the Forest*, 1912
    Oil on canvas
    43¹/₄x31⁷/₈ in. (110x81 cm)
    Städtische Galerie im Lenbachhaus, Munich,
    Bernhard Koehler-Stiftung

32. *Cows, Yellow, Red, Green*, 1912
    Oil on canvas
    24³/₈x34¹/₂ in. (62x87.5 cm)
    Städtische Galerie im Lenbachhaus, Munich,
    gift of Gabriele Münter

33. *The Monkey*, 1912
    Oil on canvas
    27³/₄x39³/₈ in. (70.4x100 cm)
    Städtische Galerie im Lenbachhaus, Munich,
    Berhard Koehler-Stiftung

34. *Deer in a Monastery Garden*, 1912
    Oil on canvas
    29³/₄x39³/₄ in. (75.7x101 cm)
    Städtische Galerie im Lenbachhaus, Munich,
    Bernhard Koehler-Stiftung

35. *Rain*, 1912
    Oil on canvas
    31⁷/₈x41¹/₂ in. (81x105.5 cm)
    Städtische Galerie im Lenbachhaus, Munich,
    Bernhard Koehler-Stiftung

36. *The Waterfall*, 1912
    Oil on canvas
    65x62¹/₄ in. (165x158 cm)
    The Robert Gore Rifkind Collection

37. *The Tiger*, 1912
    Oil on canvas
    43³/₄x43⁷/₈ in. (111x111.5 cm)
    Städtische Galerie im Lenbachhaus, Munich,
    Bernhard Koehler-Stiftung

38. *Mountains (Rocky Way/Landscape)*, 1911-12
    Oil on canvas
    51¹/₂x39³/₄ in. (130.8x101 cm)
    San Francisco Museum of Modern Art, gift of
    Women's Board and Friends of the Museum

39. *The Bewitched Mill*, 1913
    Oil on canvas
    51³/₈x35³/₄ in. (130.2x91.1 cm)
    The Art Institute of Chicago, Arthur Jerome
    Eddy Memorial Collection, 1931

40. *Painting with Cattle*, 1913
    Oil on canvas
    36¹/₄x51¹/₂ in. (92x130.8 cm)
    Bayerische Staatsgemäldesammlungen, Munich

41. *Birth of the Horses*, 1913
    Color woodcut
    8¹/₂x5³/₄ in. (21.5x14.5 cm)
    The Los Angeles County Museum of Art, the
    Robert Gore Rifkind Center for German Ex-
    pressionist Studies, Los Angeles, California

42. *Horse Asleep*, 1913 (?)
    Watercolor and ink on laid paper
    15⁷/₈x18¹/₄ in. (40.3x46.3 cm)
    Solomon R. Guggenheim Museum, New York

43. *Two Blue Horses*, 1913
    Gouache and ink on paper
    7¹/₈x5¹/₄ in. (20x13.3 cm)
    Solomon R. Guggenheim Museum, New York

44. *Colorful Flowers (Abstract Forms)*, 1913-14
    Tempera on paper
    8⁵/₈x6⁵/₈ in. (21.9x16.8 cm)
    San Diego Museum of Art, San Diego, Cali-
    fornia

45. *Seated Mythical Animal*, 1913
    Tempera on paper
    18¹/₈x15¹/₈ in. (46x38.4 cm)
    Milwaukee Art Museum, Mailwaukee, Wis-
    consin, gift of Mrs. Harry Lynde Bradley

46. *Red Deer*, 1913
    Tempera on paper
    16¹/₈x13¹/₄ in. (41x33.7 cm)
    Solomon R. Guggenheim Museum, New York

47. *Dead Deer*, 1913
    Watercolor on paper
    6³/₈x5¹/₈ in. (16.3x13 cm)
    Etta Stangl Collection, Munich

48. *Sleeping Deer*, 1913
    Tempera on paper
    14⁷/₈x17⁵/₈ in. (37.8x44.8 cm)
    Walter Feilchenfeldt Collection, Zurich

49. *Fairy Animals I*, 1913
    Tempera on paper
    10x12¹/₂ in. (25.4x31.6 cm)
    Private Collection

50. *The First Animals*, 1913
    Tempera on paper
    15³/₈x18³/₈ in. (39x46.5 cm)
    Private Collection

51. *Sleeping Animals*, 1913
    Tempera on paper
    17¹/₄x15¹/₄ in. (43.8x38.7 cm)
    Private Collection

52. *Saint Julian l'Hospitalier*, 1913
    Gouache with ink and gold on paper
    18x15³/₄ in. (45.7x40 cm)
    Solomon R. Guggenheim Museum, New York

53. *Long Yellow Horse*, 1913
    Oil on canvas
    23⁵/₈x31¹/₂ in. (60x80 cm)
    Nassau County Museum, Syosset, New York

54. *Deer in the Forest I*, 1913
    Oil on canvas
    39³/₄x41¹/₄ in. (100,9x104,7 cm)
    The Phillips Collection, Washington, bequest
    of Katherine S. Dreier, 1953

55. *Fate of the Animals*, 1913
    Oil on canvas
    76³/₄x103³/₄ in. (195x263.5 cm)
    Öffentliche Kunstsammlung Basel, Kunst-
    museum, Basel

56. *Stables*, 1913
    Oil on canvas
    28⁷/₈x62 in. (73.5x157.5 cm)
    Solomon R. Guggenheim Museum, New York

57. *The Unfortunate Land of Tirol*, 1913
    Oil on canvas
    51⁵/₈x78³/₄ in. (131.1x200 cm)
    Solomon R. Guggenheim Museum, New York

58. *The White Dog*, c. 1913-14
    Oil on canvas
    24⁵/₈x41³/₈ in. (62.5x105 cm)
    Städelscher Museumsverein e. V., Frankfurt

59. *The Wolves (Balkan War)*, 1913
    Oil on canvas
    27⁷/₈x55 in. (70.8x140 cm)
    Albright-Knox Art Gallery, Buffalo, New York,
    Charles Clifton, James G. Forsyth and Charles
    W. Goodyear Funds

60. *Mountain Goats*, 1914
    Watercolor
    8¹/₄x5¹/₂ in. (21x14 cm)
    Richard Saidenberg Collection, New York

61. *Small Composition II*, 1914
    Oil on canvas
    23³/₈x18¹/₈ in. (59.5x46 cm)
    Kunstmuseum Hannover mit Sammlung
    Sprengel, Hanover

62. *Small Composition III*, 1914
    Oil on canvas
    18¹/₄x22⁷/₈ in. (46.5x58 cm)
    Städtisches Karl Ernst Osthaus Museum,
    Hagen

63. *Fighting Forms*, 1914
    Oil on canvas
    35⁷/₈x51³/₄ in. (91x131.5 cm)
    Bayerische Staatsgemäldesammlungen, Munich

64. *Broken Forms*, 1914
    Oil on canvas
    44x33¼ in. (111.7x84.4 cm)
    Solomon R. Guggenheim Museum, New York

65. *Animals in Landscape (Painting with Bulls II)*,
    1914
    Oil on canvas
    49⅜x39⅛ (125.4x99.3 cm)
    The Detroit Institute of Arts, Detroit, Michigan, gift of Robert. H. Tannahill

66. *The Birds*, 1914
    Oil on canvas
    42⅞x39⅜ in. (109x100 cm)
    Städtische Galerie im Lenbachhaus, Munich

## Photo Credits

# Selected Bibliography

## Writings by Franz Marc

*August Macke-Franz Marc. Briefwechsel*, edited by Wolfgang Macke (Cologne, 1964).

*Briefe, Aufzeichnungen und Aphorismen*, 2 vols. (Berlin, 1920). Vol. 2 contains facsimiles of the drawings made at the front.

*Franz Marc: Schriften*, introduction by Klaus Lankheit (Cologne, 1978).

*Franz Marc: Postcards to Prince Jussuf*, edited by Peter-Klaus Schuster (Munich, 1988).

*Wassily Kandinsky, Franz Marc. Briefwechsel, Mit Briefen von und an Gabriele Münter und Marie Marc*, edited and with an introduction by Klaus Lankheit (Munich, 1983).

## Essays

Arnold, M. "Problematik eines Klassikers," *Weltkunst* (1980) vol. 50, pp. 2426-29.

Behne, Adolf. "Franz Marc," *Die Tat*, 8, no. 2 (1916-17), pp. 1028-29.

Benninghoff, Ludwig. "Ehrenmal und Vermächtnis. In memoriam Franz Marc," *Der Kreis*, 7 (1930), pp. 271-76.

Bünemann, Hermann. "Das Tier in der Kunst von Franz Marc," *Kunst* (edited by Franz Roh), 1 (1948), pp. 65-72.

Däubler, Theodor. "Franz Marc," *Die Neue Rundschau*, 27 (1916), pp. 564-67. Reprinted in *Der neue Standpunkt*, edited by Fritz Löffler (Dresden, 1957), pp. 117-23.

——. "Franz Marc und die Tiere," *Das Kunstwerk*, 1 (1946-47), pp. 40-41.

Eberlein, Kurt Carl. "Franz Marc und die Kunst unserer Zeit. Eine Deutung," *Genius*, 3, no. 2 (1921), pp. 173-79.

Goldwater, Robert J. "The Primitivism of the *Blaue Reiter*," in *Primitivism in Modern Art* (New York, 1938). Revised edition, 1967, pp. 125-44, 200.

Gordon, Donald. "Content by Contradiction (Nietzsche's Bequest to the German Expressionists)," *Art in America*, 70 (1982), pp. 78-80.

——. "Marc and Friedrich Again: Expressionism as Departure from Romanticism," *Source*, VI (1981), pp. 29-31.

Keimer-Dinkelsbühl, Elisabeth. "Der junge Franz Marc," *Vossische Zeitung*, August 2, 1930.

Langner, Johannes. "'Symbole auf die Altäre der kommenden geistigen Religion.' Zur Sakralisierung des Tierbildes bei Franz Marc," *Jahrbuch der Staatlichen Kunstsammlung in Baden-Württemberg* (1981), pp. 79-98.

Lankheit, Klaus. "Zur Geschichte des Blauen Reiters," *Der Cicerone*, no. 3 (1949), pp. 110-14.

Levine, Frederick S. "The Iconography of Franz Marc's *Fate of the Animals*," *The Art Bulletin*, 58 (1976), pp. 269-77.

Meier, Andreas. "Der fünfte Tag der Schöpfung," *Du*, no. 3 (1987), pp. 4-53.

Moffit, J. F. "'Fighting Forms: the *Fate of the Animals*': the Occultist Origins of Franz Marc's Farbentheorie," *Artibus et Historiae*, 12 (1986) pp. 107-26.

Rudenstine, Angelica Zander. "Franz Marc," in *The Guggenheim Museum: Paintings 1880-1945* (New York, 1976).

Schmidt, Georg. "Die '*Tierschicksale*' von Franz Marc," *Du*, no. 4 (1956), pp. 39-40.

Zahn, Leopold, "Franz Marc und der Krieg," *Das Kunstwerk*, 6, no. 5 (1952), p. 14.

## Monographs

Büneman, Hermann. *Franz Marc—Zeichnungen und Aquarelle*. 3rd. ed. (Munich, 1960).

Gollek, Rosel. *Franz Marc. 1880-1916* (Munich, 1980).

*Franz Marc. Unteilbares Sein. Aquarelle und Zeichnungen* (Cologne, 1959). With a reprint of the essay "Die Konstruktiven Ideen der neuen Malerei" by Franz Marc and essays by Klaus Lankheit: "Franz Marc—Der Mensch und das Werk" and "Zu den Farbtafeln." English edition: *Franz Marc. Watercolors-Drawings-Writings* (London and New York, 1960).

*Franz Marc im Urteil seiner Zeit.* Introduction and commentary by Klaus Lankheit. Includes essays by Hermann Nohl, August Caselmann, Helmuth Macke, Reinhard Piper, Wassily Kandinsky, Paul Klee, Wilhelm Reinhold Valentiner, Hans Schilling, Else Lasker-Schüler, Theodore Däubler, Wilhelm Hausenstein, Rainer Maria Rilke, Walter Bombe, Lothar Schreyer, Theodor Heuss (Cologne, 1960).

Lankheit, Klaus. *Franz Marc.* Edited and with an epilogue by Maria Marc. Vol. 3 in the series *Kunst unserer Zeit* (Berlin, 1950).

——. *Franz Marc—Der Turm der Blauen Pferde* (Stuttgart, 1961).

——. *Franz Marc: Katalog der Werke* (Cologne, 1970).

——. *Franz Marc: Sein Leben und seine Kunst* (Cologne, 1976).

Levine, Frederick S. *The Apocalyptic Vision: The Art of Franz Marc as German Expressionism* (New York, 1979).

März, Roland. *Franz Marc.* (Berlin, 1984).

Rosenthal, Mark. *Franz Marc: 1880-1916*. With contributions by Frederick S. Levine, Klaus Lankheit, Ida Katherine Rigby (Berkeley, 1979).

Schardt, Alois J. *Franz Marc* (Berlin, 1936).

Schmidt, Georg. *Franz Marc und die deutsche Malerei des 19. und 20. Jahrhunderts* (Berlin, 1957).

Tobien, Felicitas. *Franz Marc* (Ramerding, 1982).